# Digital
# Photography
# Manual

Published by: Haynes Publishing
Sparkford, Yeovil, Somerset BA22 7JJ
Tel: 01063 442030 Fax: 01963 440001
Int. tel: +44 1963 442030 Fax: +44 1963 440001
E-mail: sales@haynes-manuals.co.uk
Web site: www.haynes.co.uk

British Library Cataloguing in Publication Data:
A catalogue record for this book is available from the British Library

ISBN 1 85960 995 3

Printed in Britain by J. H. Haynes & Co. Ltd, Sparkford

Throughout this book, trademarked names are used. Rather than put a
trademark symbol after every occurrence of a trademarked name, we use
the names in an editorial fashion only, and to the benefit of the trademark
owner, with no intention of infringement of the trademark. Where such
designations appear in this book, they have been printed with initial caps.

Whilst we at J. H. Haynes & Co. Ltd strive to ensure the accuracy and
completeness of the information in this manual, it is provided entirely at the
risk of the user. Neither the company nor the author can accept liability for
any errors, omissions or damage resulting therefrom. In particular, users
should be aware that component and accessory manufacturers, and
software providers, can change specifications without notice, thus
appropriate professional advice should always be sought.

# Digital Photography Manual

creating better pictures from camera to computer

**Winn L. Rosch**

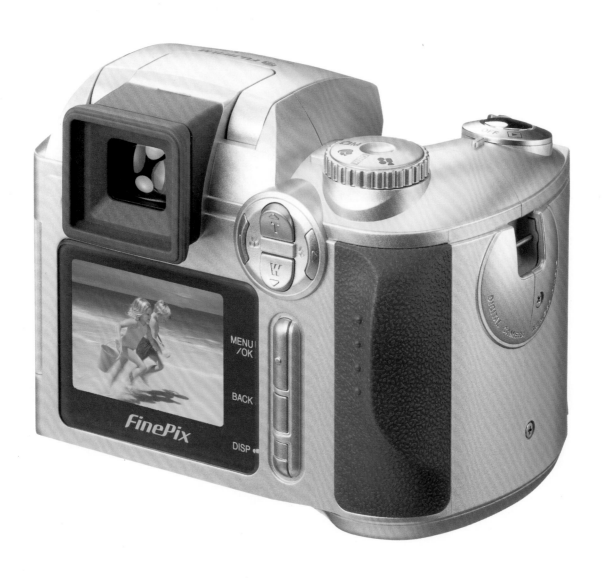

# Contents

# Introduction

A digital camera is the great deception. It looks like an ordinary film camera. You hold it the same way, peer through a little window when you want to take a picture. You push a shutter button as with any other camera. And you get photographs – prints – that look indistinguishable from ordinary photographs. Well, maybe a bit better. But that little camera hides a big secret. It marks the biggest change in photography since the Daguerreotype – and even before that. Ever since Thomas Wedgewood noted that light makes silver salts turn dark more than 200 years ago, photography has relied on chemical changes to capture images. Not the digital camera. It measures light directly – with digital precision.

But even that technical breakthrough pales in comparison to the result. Digital cameras produce digital images. Although prints may fade, the digital originals have all their colours and details forever preserved. At the same time, digital images are more easily changed. Using inexpensive (often free) software on your computer, you can alter and enhance your photos using special effects that otherwise would take an investment of thousands of pounds for camera attachments and days of experiments with film. With digital photography, you can easily erase wires and intruders from your photos or put yourself into any picture you take. Moreover, you can post digital photos on the Web or e-mail them instantly to friends and family anywhere in the world.

Where once digital cameras were a curiosity, they are now an inevitability. Few doubt that the era of the film camera is over. In fact, soon you won't have a need for the extra word 'digital' when talking about photography.

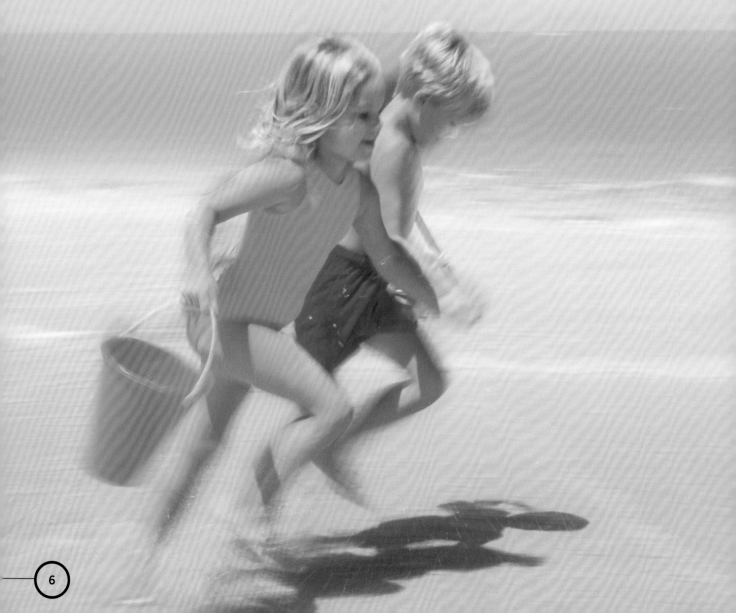

Think ahead ten, twenty or more years when film-based photography may have long been laid to rest, a time when your grandchildren may ask you what film photography used to be like. They will find it hard to believe that you had to wait for your film to be processed before you could see your pictures; or that, if you did the processing yourself, you had to dabble in environmentally unfriendly chemicals. That you had to carry little canisters of light-heat-x-ray sensitive film everywhere you went will seem just as incredible to them as your having to save the acetate negatives and transparencies in special sleeves and boxes to keep them free from dust and scratches. And, if you wanted to remove a pimple from a portrait, you had to employ the expensive services of a laboratory, or set to with brush and paint – well, you just must be making it up!

Now that we have digital photography, no one but an artist or eccentric would ever think to put up with the demands of the film camera. Digital makes life and photography so much easier, convenient, fast and affordable, and getting started is easier than you think – especially with this book to guide you on your way.

No matter what your experience or level of skill in photography, the first thing you need if you are to go digital is, of course, a digital camera. So, we'll start by helping you choose a camera based on what you plan to do – everything from taking snapshots to making studio-quality photos. We'll look at different kinds and styles of cameras and the features that distinguish them so you can choose the best for your own particular photo-shooting needs.

From there, we'll begin using your new camera. Our starting point will be conventional photography. We'll look at how digital is different and the basics you need to know to use your camera effectively.

If you aspire to do more than point your new camera in the right direction and hope for the best, we'll offer some tips to show you how to make your digital photographs better. We'll look at common photographic situations and explore different ways of treating them, focusing particularly on using digital techniques.

Going digital lets you manipulate your photos to eliminate flaws, to enhance them for greater impact, and to make them stand out. We'll look at some of the most common changes you may want to make, and give you step-by-step guidance.

Once you have finished photos, you're going to want to share them. We'll examine all the possibilities, from how to make the best prints using your computer to publishing them on the Web and sharing them through e-mail.

And finally, we'll look at saving your digital photos for posterity – or just to jog your own memory.

1

PART

# Introduction to Digital Cameras

PART  # Anatomy of a digital camera

If you're familiar with film cameras, you'll notice a few differences. The main one is that the digital camera does not open up to let you put film inside. You don't need film – that's one of the big advantages of going digital. So, there's no reason to wind and rewind (and no film advance lever to wear out your thumb).

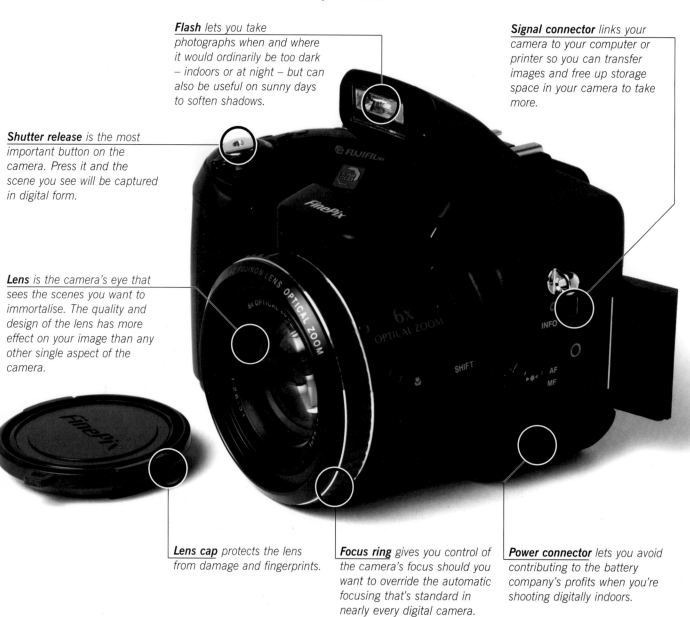

**Flash** *lets you take photographs when and where it would ordinarily be too dark – indoors or at night – but can also be useful on sunny days to soften shadows.*

**Signal connector** *links your camera to your computer or printer so you can transfer images and free up storage space in your camera to take more.*

**Shutter release** *is the most important button on the camera. Press it and the scene you see will be captured in digital form.*

**Lens** *is the camera's eye that sees the scenes you want to immortalise. The quality and design of the lens has more effect on your image than any other single aspect of the camera.*

**Lens cap** *protects the lens from damage and fingerprints.*

**Focus ring** *gives you control of the camera's focus should you want to override the automatic focusing that's standard in nearly every digital camera.*

**Power connector** *lets you avoid contributing to the battery company's profits when you're shooting digitally indoors.*

Most digital cameras look like their film-based forebears – lens in front, viewfinder on top. In fact, for the most part they work like film cameras. Then you encounter extra connectors and slots, and things that look as though they'd be better off untouched. There's a trace of the 23rd century about a digital camera – and a bit of the 19th – but once you get to know all the pieces and how they work together to take today's best pictures, you'll think of your digital camera as an old friend.

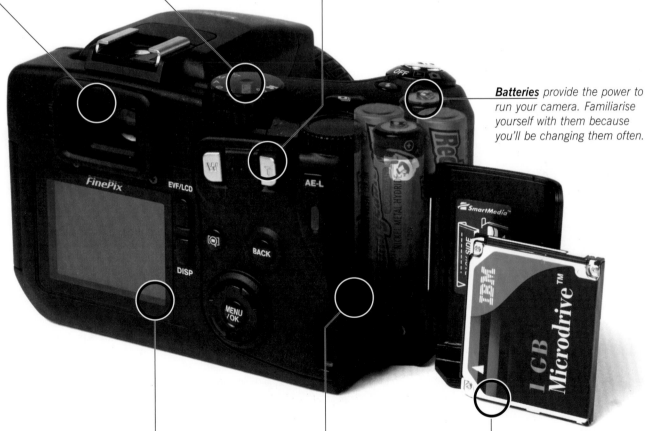

**Viewfinder** *gives you a preview of the scene you're going to photograph so you can see what you will and won't capture in digital form.*

**Mode control** *lets you tailor how your camera works so you can make it behave the way you want in every photographic situation.*

**Zoom control** *changes the camera's field of view so you can focus on a single, distant object or capture a wide scene or large crowd in a single shot.*

**Batteries** *provide the power to run your camera. Familiarise yourself with them because you'll be changing them often.*

**LCD viewer** *lets you both preview and review your images so you can see your results immediately, and decide what to keep and what to shoot again.*

**Card slot** *holds the memory card, allowing you to interchange cards to increase your picture capacity, so you don't have to download images so often.*

**Memory card** *is the digital equivalent of film. It stores your images until you download them into your computer or directly to a photo printer.*

PART **1**

# Is digital photography for you?

If you're thinking at all about photography today, you should be thinking digital. With every technological tweak, digital becomes a better choice. Only in a handful of applications does a conventional film camera make sense any more. That's not to say that digital is the same as film photography. There are a number of differences you'll have to master if you're moving from conventional to digital picture-taking. But, overall, digital is the better choice for modern photography.

## Where film wins

Someday, all cameras will be digital, but we're not there yet. In today's world, digital already excels at most of what you want a camera for, but several applications (and some people) are better suited to conventional film photography.

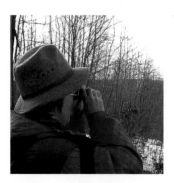

*Wilderness photography* often suits film because its electrical needs are minimal (digital weighs you down with a load of batteries which may fail at a critical moment) and you don't need to carry kit for downloading and storage.

*Underwater photography* is still easiest on film. You can find both disposable and professional cameras optimised for the depths. But underwater housings and new digital cameras will soon turn the tables.

*Unexpected moments* when you don't have a camera, it means grabbing what's available. Most of the time that will be a disposable film camera from the chemists. Although it's possible to get hold of a digital camera for about the price of a disposable film camera plus developing, you won't find one in an emergency.

*Fine art* often means film photography. For example, you might want the intimate control of a view camera, or film might lend itself to a particular kind of manipulation. Film is a tool that can be used by artists, but increasingly digital is, too.

## How digital is different

If you're like most people, a digital camera is not your first camera. You've been shooting with any one of a variety of ordinary film cameras for years. Equipment makers know that, and they aim to make their digital product the same old familiar friends as film cameras, to the extent of marking lenses as if they sat securely on the end of a 35mm camera. That's good because much of what you know about photography applies to digital as well as film. But some of the underlying premises may be different.

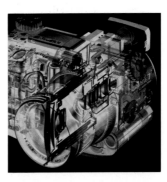

*Shoot now; edit later. Making a shot with film costs you with every exposure – 25 to 50p per exposure for film and developing alone. Professionals on assignment with unlimited budget may go through hundreds of rolls, but if you're shooting for fun or on a budget, your accountant might be sitting on your shoulder whispering 'another 50p' with every shot. With digital, each exposure costs you almost nothing. Take all you want.*

*Plan for your resources. With film, you had to fill your bag with enough film to accommodate each exposure you planned – and several more for the unexpected. With digital, you have to plan for power and storage. You won't want to see the 'battery low' indicator when the rhinos are chasing you in Zaire. You'll need to plan far ahead for a wilderness trek.*

*Forget external dangers. With film, you had to be on-guard when travelling lest the x-ray machine at the airport turned all your photos red. With digital, there's no radiation worries. And you don't have to worry about anyone opening your camera for a peek at the film. Digital images can be lost – those cards can fall from your pocket – but they are easier to safeguard. Download them to your notebook or the web.*

*Anticipate. With any camera, one of the big differences between good and great photographers and photographs is the ability to anticipate. With a film camera you have a few milliseconds of delay between pushing the button and getting the shot. With digital, the wait is longer. Pros soon learn to anticipate more eagerly. So will you.*

## FIVE REASONS FOR GOING DIGITAL

**Convenience** No one wants to wait. You see results immediately with digital photography. That means you can embarrass your friends on-the-spot or retake (over and over again) a shot that doesn't work out.

**Flexibility** You can make prints on paper or publish images electronically.

**Editability** You can correct and improve digital photos with your computer, changing their size, colour, even content just by pushing your mouse around. No darkroom necessary – ever.

**Environmentally friendly** Digital eliminates the ecological drawbacks of conventional photography: No film, no toxic developers, no wasted prints.

**Price** Think parity. Although the cost of entry used to be higher for digital cameras, technology has trimmed the difference. The prices of a single-lens reflex film camera and a prosumer digital camera are about the same, and high-end (or professional) cameras are becoming comparable. In the long run, digital photography is definitely less expensive because there are virtually no materials costs.

# PART 1

# What kind of camera is right for you?

There's a dazzling array of digital cameras on the market at an equally dazzling range of prices. The question is, which one is right for you? Your most important consideration should be what you're going to use it for.

To make things just a bit easier, that dazzling array can be divided into four general types – point-and-shoot, mainstream, so-called 'prosumer' and the serious kit for really serious money which the professionals use. However, the dividing line between point-and-shoot and mainstream cameras is indistinct.

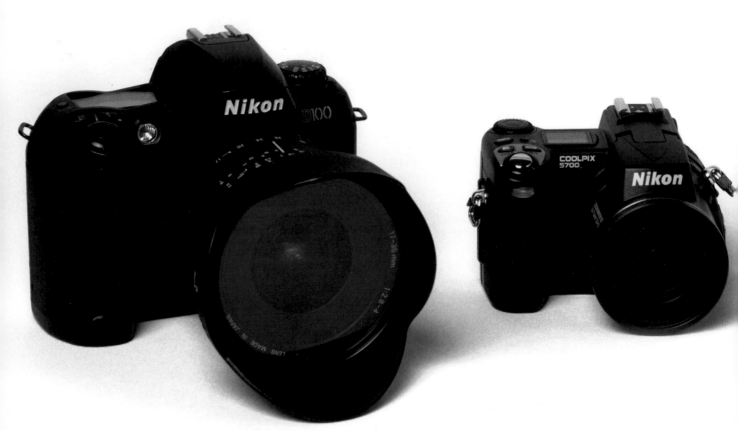

## Professional systems

Unless you earn your living from photography, and can make your kit recoup its cost, you'll probably do no more than drool over these cameras. We're in the land of digital SLR, interchangeable lenses and price tags written in thousands of pounds. Expect to be asked anything from £2,000 to £6,000 – and that may be just for the camera body – way out of the hobby sphere for all but the wealthy.

## Prosumer

They call it prosumer because you get quality close or equal to the professionals but at a price that's nearer a consumer's budget. So, if you want your camera to take the sharpest possible pictures – as good or better than those you see in magazines – and you'd not jib at spending £650 and maybe a good deal more, then this is the area of the shop you need to look in.

## Mainstream

We are still really in point-and-shoot territory, but these cameras include a range of features, have a greater effective pixel rating and will give you much better picture quality. With mainstream cameras and beyond you have the option – point-and-shoot for itchy trigger fingers and manual override when you want to do better (or at least try). If you want a good digital camera, but the sky is not the limit, then this is the range to look at. Prices reflect each camera's respective capabilities. Expect to pay from £200 to £500. You are looking at a practical tool here, not a toy.

## Point-and-shoot

If you are not interested in user control and simply want a fun camera which you can pull out of your pocket, aim and press, then a basic point-and-shoot is the one for you – maybe the cheaper the better so you won't have to worry too much about dropping it or losing it. Your picture quality may not be anywhere near studio standard, but you are probably only planning to e-mail your snaps to your friends and it'll be fine for that. Prices start around £30 and go on up to about £200 and just over in this bracket.

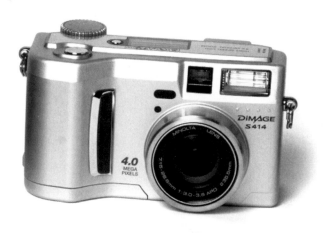

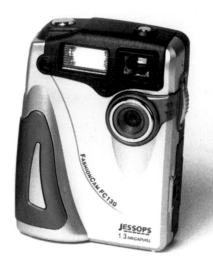

## Other alternatives

A digital camera is only one of many photographic tools. You'll find other tools more suited to some applications, even when confined to the realm of digital technology. If all you want to do is put your face on the Internet, a webcam may produce all the digital images you need. Or, you can grab still photos with many of today's digital camcorders. You can also take your collection of ordinary film-based photographs into the world of digital technology by using a scanner.

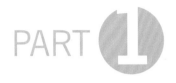

# Point-and-shoot cameras

The point-and-shoot camera is for the quick-draw snapshot. They are truly meant to capture an instant and, with no controls to bother about, except the shutter release, they are fast-handling. You can draw and fire the shutter before your subject can reel back in horror or break into a mood-ruining smile.

Point-and-shoots are not for perfect images fit for scientific study or coffee-table books. They are for cheap and cheerful memory-jogger photos to go in your album to bring to mind, at some future date, past times of laughter and tears and long-forgotten friends.

To use them you don't need to know anything about photography, but professionals are known to carry them for snapshots on their days off. They are designed for minimum wear-and-tear on your mind, taking care of all the variables except one – picking a subject. All you have to do is aim the camera and push a button, and your subject is immortalised.

The point-and-shoot class extends from the most basic cameras – the cheapest you can buy – to the moderately pricey range of mainstream cameras. In fact, most mainstream cameras are point-and-shoot, although they have pretensions of giving you more than mere snapshots. The low-end point-and-shoot camera gives you no choice – you always have to click your images in mindless mode. This is the digital equivalent of the one-use disposable film camera. But, because you're not restricted to a length of film, there's no compelling reason to toss your digital camera away. Downloading your images is equivalent to buying a new disposable camera. In other words, at the low end you'll find both good deals and a good deal of photographic fun.

Minimal built-in flash

Minimal controls

2.1 MP
4x digital zoom

Optical viewfinder

Non-removable memory (in many models)

Fixed-focus lens

5.9mm

hp photosmart 320

Slow serial or USB connection

# What a basic point-and-shoot is good for

*A basic point-and-shoot is all you need for snapshots.*

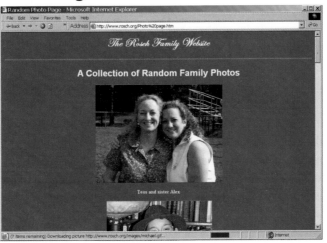

*The lower resolution of an inexpensive point-and-shoot camera is perfect for the Web. If your club or small business has a website, a point-and-shoot camera gives you a quick-and-easy way to put pictures on every page (though you won't be able to make close-ups).*

*Carry a point-and-shoot camera with you at all times.*

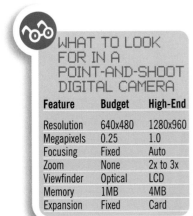

## WHAT TO LOOK FOR IN A POINT-AND-SHOOT DIGITAL CAMERA

| Feature | Budget | High-End |
|---|---|---|
| Resolution | 640x480 | 1280x960 |
| Megapixels | 0.25 | 1.0 |
| Focusing | Fixed | Auto |
| Zoom | None | 2x to 3x |
| Viewfinder | Optical | LCD |
| Memory | 1MB | 4MB |
| Expansion | Fixed | Card |

*You can develop your own fast-and-loose style with a point-and-shoot camera and the low resolution and slight blur may be just the edge you need in your work. So, don't discount the artistic possibilities of an inexpensive camera.*

*A point-and-shoot camera is a great introduction to photography for children. There's little to go wrong, no adjustments to make and no film or processing to worry about wasting money on.*

# PART  **Mainstream cameras**

**This is where technology and reasonable pricing converge. Today that means you get a camera that's every bit as good as a mainstream film camera – more than good enough for on-line and newsletters. Such cameras are imaging workhorses, which can be used to take photos for fun and albums as well as for the Web and your cv. In today's technological age, a mainstream digital camera is a necessary household tool. You can send a photo of a chair to the upholsterer for a quote, show your doctor your child's rash or let potential on-line customers make a choice from your litter of puppies.**

The mainstream camera recognises that much of the time we don't want to bother with all the exquisite details of photography – reading light levels, setting f-stops and focusing – and takes care of everything when you want. It operates as a point-and-shoot camera but makes higher-quality images as befits its higher price. When you want to do more, to try your hand at selective focus or compensate for backlighting, the mainstream camera yields to your control. You also have the ability to preview and review your images on a built-in LCD panel, and you can extend the capacity of the camera's removable memory card (or stick) by ruthlessly editing the images you capture inside the camera.

The important characteristics of a mainstream camera include the LCD display, automatic focusing, a moderate amount of optical zoom, expandable memory, and at least two megapixels of resolution (three is, of course, better). That's good enough to make your own 25cm x 20cm inkjet prints.

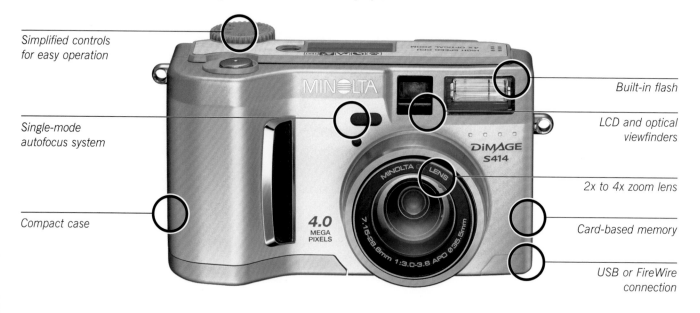

*Simplified controls for easy operation*

*Single-mode autofocus system*

*Compact case*

*Built-in flash*

*LCD and optical viewfinders*

*2x to 4x zoom lens*

*Card-based memory*

*USB or FireWire connection*

# What mainstream cameras are good for

Print your family photos off and display them in your home.

*They're perfect for nearly all Web applications. You have enough resolution to severely crop your images to frame things exactly right. Most mainstream cameras also include a 'macro' focusing feature that allows you to take close-ups for illustrating items for on-line auctions.*

*Their versatility means that they'll tackle most jobs from point-and-shoot fun shots to more formal work. Although most mainstream cameras fall short of the quality needed in professional publishing, high-end models will give professional cameras a good run for their money.*

## BETTER MAINSTREAM CAMERAS HAVE ...

- Higher resolution (at least 3.3 megapixels)
- Built-in flash with red-eye reduction
- Longer zoom range (3x or higher)
- Larger memory card often included
- Image editing software and transfer cables
- Multiple exposure modes
- Manual and automatic focusing
- Larger LCD screens, 1.6in or larger
- Extremely compact design, the size of a deck of playing cards

# PART 1

# **Prosumer cameras**

With quality on a par with the best professional cameras and prices temptingly close to affordability (not in the stratosphere as with much pro gear), the so-called prosumer camera – a word that reflects the half-breed design that's both professional and consumer – represents the most exciting area of digital photography. For many manufacturers this is the top-of-the-line, the place to show off new ideas and features, the place to tempt you with the most desirable blend of features, quality and price. And some prosumer cameras just look neat.

What do you get for your money? Usually the best image sensors – that is, the highest resolution – on the market. Today's best prosumer cameras deliver about six megapixels of resolution, good enough to rival classic 35mm film in blow-ups larger than 40cm x 30cm. In addition, most combine point-and-shoot ease of use with semi-manual modes that let you experiment with images as you would with film.

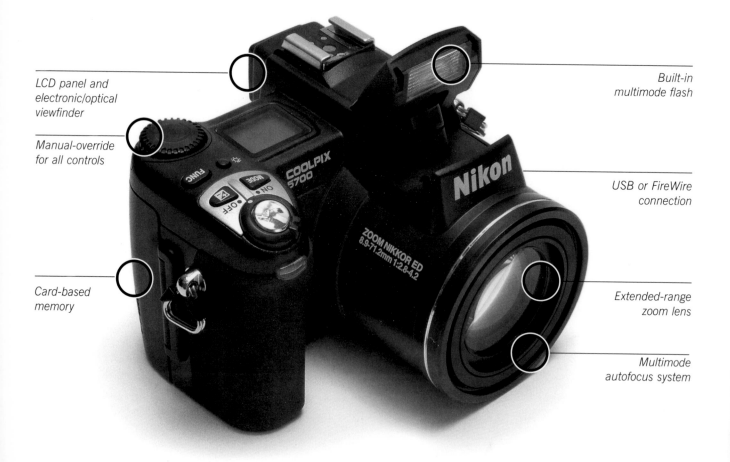

LCD panel and electronic/optical viewfinder

Manual-override for all controls

Card-based memory

Built-in multimode flash

USB or FireWire connection

Extended-range zoom lens

Multimode autofocus system

What you don't get (at least for now) is interchangeable lenses, which remain the prerogative of the next (and final) step up, the true professional camera. Making up for that shortcoming, most prosumer cameras come equipped with a single lens with moderate zoom capabilities so you never have the need to change lenses. In this price range, a 3x zoom is the minimum you should expect. The best go all the way to 10x – with such a range you likely won't miss having interchangeable lenses, unless you want to go super-wide (fisheye) or telephoto to the moon. In fact, photo professionals travelling light or on a tight budget may opt for a prosumer camera.

If you're a serious photo hobbyist, you'll find everything you dreamt of in a prosumer camera. It will not only deliver the best quality images available today but also give you the option of video and more features than you'll be able to grasp in a lifetime. A prosumer camera will handle any photographic task you have, from capturing your children's birthday parties for your family album to illustrating the next book you write.

## PROSUMER AND PROFESSIONAL CAMERAS COMPARED

| Feature | Prosumer | Professional |
|---|---|---|
| Lens | Wide zoom range | Interchangeable lenses |
| Flash | Built-in, full-feature | Contacts for high-powered commercial strobes |
| Viewfinder | Optical or electronic | True SLR design |
| Resolution | 5 to 6 megapixels | Same |
| Shooting speed | One frame per second | Multiple frames per second |
| Focus | Multimode autofocus with manual override | Same |
| Software | Image editing software included | Optional |
| Exposure modes | Multiple exposure modes with manual override | Same |
| Shutter | Several shutter speeds | Large number of shutter speeds |
| View panel | Built-in LCD | Same |

# What prosumer cameras are good for

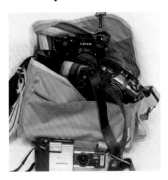

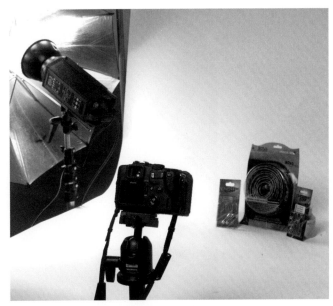

*Choose it when you want to travel light. You won't have to carry a bag of lenses and accessories because nearly everything you need is built-in. Alternatively, tuck it into the bag along with your other photographic kit as a spare.*

*Display your artistic pictures in a prominent place ... be proud!*

*They're fully capable of coping with any photographic project, even commercial work since, with such a camera, you'll be able to take professional-quality pictures.*

PART 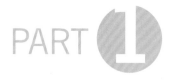 # Professional cameras

Working professionals have wielded digital cameras for years. Almost as soon as the technology became available, they discovered that the time saved by going digital paid for the equipment costs after a few big jobs. And that's when a digital back (which means little more than a sensor in a box) sold for around £20,000. Digital meant no darkroom time, less time to set up shots, no Polaroids, no waiting for proofs, no waste, easier airbrushing and better results overall. Photojournalists could modem their shots back to the newspaper in seconds. For the working pro, the digital camera was magical.

It still is. And, for professional-level quality, it's still expensive. Those £20,000 backs for Hasselblad cameras are still £20,000 backs for Hasselblad cameras. A good digital single-lens reflex camera still costs £2,000 to £3,000 or more – but some newer models from companies like Fuji, Minolta, Nikon and Sigma aspire higher than prosumer models at intriguing prices, targeting around £1,000 to £2,000. That's about what you might pay for a serious film camera.

*Traditional control placement*

*True single-lens reflex*

*Bulletproof mechanical design*

*Interchangeable lens system*

*External flash contact*

*USB or FireWire connection*

That's still a hefty investment. What does the professional – or serious amateur – get for this kind of money? A system camera. That means the camera is the foundation for a complete arsenal of picture-taking equipment and accessories.

The one design element that defines a professional camera is interchangeable lenses. That is, with the press of a button, the lens on the front of the camera twists off and can be replaced by another lens of different focal length. In effect, changing the lenses changes the photographer's point of view. It's like having several cameras in one.

Currently the major professional digital cameras are designed around the lenses and accessories used by major 35mm cameras. That's great because it gives the pro the chance to move to digital and keep the same lenses and stuff. But the transition isn't precise. Today's high-resolution image sensors are smaller in area than the frame of 35mm film. It's like the lens has zoomed to the centre of the image. In practical terms, it increases the effective focal length of every lens, so that a wide-angle lens operates more like a normal lens, and a normal lens is a short telephoto. The effective focal length (in terms of size of the image) is 1.3 to 1.5 times longer than on a 35mm camera. (The exception to this rule is the Contax N Digital, which has a sensor the size of a 35mm frame and needs no focal length adjustment.)

## WHY INTERCHANGEABLE LENSES?

A pro carries a bag of lenses because each one has a special and important role.

| | |
|---|---|
| **True fish-eye lens** | Dramatic effects |
| **Extreme wide angle** | Panoramas, interiors |
| **Moderate wide angle with wide aperture** | Indoor group portraits |
| **Moderate telephoto with wide aperture** | Portraits |
| **Extreme telephoto** | Nature and paparazzi photography |
| **Macro lens** | Close-ups of small objects (flowers, stamps, etc.) |
| **Soft focus** | Portraits, special effects |
| **Telescope adapters** | Astrophotography |
| **Microscope adapters** | Microphotography |

## The benefits of professional cameras

*Build quality. These cameras are made to withstand daily abuse at the hands of working professionals. They are expected to (and usually do) work for years under the roughest conditions (and handing) with only minor servicing.*

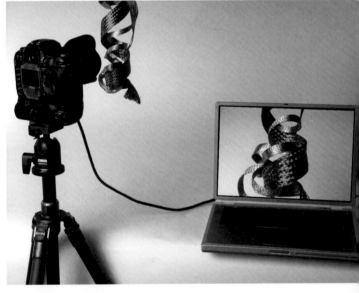

*Some have software that allows the camera to be operated from the computer using the monitor as a huge viewfinder.*

**2**

PART **2** # Digital Camera Technology

# PART  Image sensors

Instead of silver-based film to register and record light, digital cameras use a special relatively large integrated circuit called an *image sensor*. As with film, an image sensor sits at the focal point of the camera lens. Unlike film, however, it is permanently mounted, an intrinsic piece of camera hardware that never needs to be changed.

The digital camera image sensor isn't much to look at but it has a very high profile function.

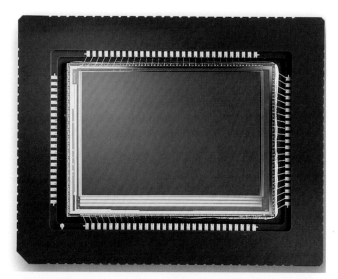

The sensor captures an image electrically. It detects photons and translates their energy into a minute electrical current that circuits can sense, amplify, digitise and store. A single sensor is actually an array of individual light sensors, each one forming one of the millions of dots that make up a full image. The number of individual elements in the array determines the *resolution* of the camera.

Image sensors are often termed CCDs, an acronym for Charge-Coupled Devices, which describes the technology that converts light to electricity. Many cameras use image sensors based on CMOS (Complementary Metal Oxide Semiconductor) technology that, strictly speaking, are not CCDs, but people call them that anyway. In general, CMOS sensors are less expensive but less sensitive than CCD sensors, but refinements to both technologies are erasing those differences.

The chief difference between image sensors and the cameras built around them is the number of individual elements or *pixels* (a contraction of *picture elements)* in the sensor. The more pixels, the higher the resolution of the image sensor, and the more detailed the pictures it captures.

## Resolution

To register colour, cameras require the signals from three separate elements, one each to individually register green, red and blue light. Most digital cameras use an array of sensors that alternate green with each of the other two colours. Using interpolation algorithms, the camera calculates three individual colour values at each element position regardless of its colour sensitivity. Thus a million pixel (megapixel) sensor has only a million elements, unlike other computer colour systems such as printers and monitors, which count pixels as triads of three elements (one each green, red and blue). The megapixel ratings that characterise camera resolution are based on these inflated pixel counts.

To put pixels in perspective, no 35mm camera and few films can resolve 100 lines per millimetre across a 24mm x 36mm frame. By that count, an image sensor with 2,400 x 3,600 pixels (about 8.5 megapixels) would be sharper than anything a 35mm film camera can produce. Many people regard six megapixels to be the equivalent of the best 35mm film cameras.

Image sensors interpolate the colour at each pixel position by weighing light intensity measured at adjacent sensor elements of different colours.

## Size

The physical size of the image sensor affects other elements of the design of a digital camera. For example, the coverage of the lens usually is tailored to match the sensor size. In general, image sensors are smaller than film frames, so the lenses on digital cameras can be smaller because they cover less area. For example, today's six-megapixel sensors are about two-thirds the size of a 35mm frame.

This size difference becomes a problem for interchangeable-lens cameras. Using a standard 35mm lens on a smaller sensor makes the lens act as if it had a longer focal length because only the centre portion of the image gets captured. As a result, many less expensive digital cameras using the interchangeable lenses from 35mm film cameras (such as the Nikon D100 and Fuji FinePix S2) require you to multiply the focal length of the lens by a factor of about 1.3–1.5 when used on the digital camera. Although telephoto range is enhanced, extreme wide-angle photography is not possible with such cameras.

A few (usually the most expensive) interchangeable-lens digital cameras use image sensors that match the size of 35mm film frames and require no such focal-length conversion.

## Sensitivity

The image sensor also determines the light sensitivity of a digital camera. Most sensors are more sensitive than all but the fastest film. This sensitivity can be adjusted (reduced) electrically. Most digital cameras adjust the sensitivity of their sensors to be the equivalent of standard film types. For example, most cameras operate with an effective film speed of ISO 100. Better cameras allow you to alter their sensitivity, for example, to achieve a higher speed ratio of ISO 400.

Because digital camera sensors are smaller than film frames, on interchangeable lens cameras designed to use 35mm lenses, they exaggerate the focal length and use only the central part of the lens image.

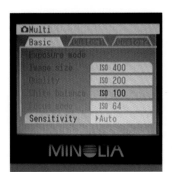

Many digital cameras allow you to set their light sensitivity as you would film speed on a conventional camera.

# PART 2 Lenses

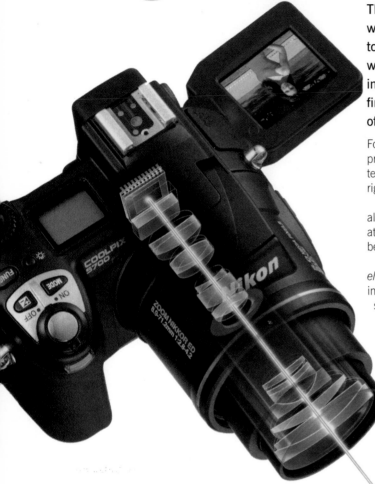

The lens is your camera's eye. It must see the image you want to capture, but how it sees is even more important to the photos you take. Your camera's lens determines when you can take a picture, how much of a scene fits into an image, and where your own eye is drawn in the final image. And, its quality directly influences the quality of your results.

For all its importance, however, the camera lens is essentially a primitive thing, utterly resistant to the miniaturisation of modern technology. It operates in the non-digital realm of optics and rigidly follows optical laws formulated hundreds of years ago.

A wide variety of lenses are used by digital cameras, although all are based on the same concepts and principles. Here's a look at what you need to know about lenses to judge the differences between digital cameras.

A magnifying glass is a lens, but to a camera it's a lens *element*. No single lens element can be perfect or create perfect images. Camera lenses are made from multiple elements, sometimes dozens, designed and chosen to compensate for the defects in one another and add convenience features such as zooming.

The elements are glued together into *groups* and carefully spaced to produce the desired optical effects, the arrangement determined by computer program. The layout of the elements is the *optical formula* of the lens. The chief modern improvements are new lens materials and new manufacturing techniques that allow aspherical elements, which simplify optical formulae.

The light path through a lens to the CCD is illustrated here on a Nikon Coolpix 5700.

A wide-angle lens packs a panorama into a single image, filling it with detail or allowing you to capture a crowd, a room, or the entire horizon in one shot.

But taken to the extreme, wide-angle lenses distort shapes, particularly at the edges of the frame.

Wide-angle lenses also distort perspective, making spaces seem larger. A small room becomes huge with a wide angle lens. Close-up objects loom large compared to the background.

## Focal length

Engineers have a way of draining all the fun from things. For you, the focal length of a lens describes how much you see, the angle of view. A lens with a short focal length is called a *wide-angle lens* and sees what your eyes would have to scan, almost as a panorama. A long focal length lens, sometimes called a *telephoto lens*, brings distance close, makes objects bigger, and directs your attention to particular details.

For the engineer, the focal length describes the distance between the lens and where it is most sharply focused – not the back of the lens but its optic centre or nodal point which, confusingly, can be some distance in front of or behind the physical lens. Don't worry about it. Just remember longer means closer when you take a photo.

To complicate matters, the angle of view (whether a lens is wide angle or telephoto) for a given focal length depends on the size of the image you want to make, which corresponds to the size of the image sensor in a digital camera. Because most digital cameras have sensors smaller than a frame of 35mm film, a normal lens for a digital camera has a shorter focal length than the 50mm that's regarded as normal for 35mm photography.

To ease the transition from film to digital photography, many digital camera makers indicate the 35mm equivalent focal length of their lenses – that is, the focal length of a lens for a 35mm camera that would give the equivalent field of view.

Telephoto lenses focus your attention on a small part of a scene.

Long focal lengths compress distance, making faraway objects appear closer.

## Aperture

Literally speaking, an aperture is nothing more than a hole, but an expensive one when it comes to cameras. The aperture is the hole in the lens through which light can get to the image sensor. The bigger it is, the bigger the fraction of the available light it lets in, so the less light you need to take a picture and, generally, the most expensive the lens.

Varying the size of the aperture helps a camera of any kind cope with light conditions. When light is too bright, its intensity can overwhelm the image sensor; too dim, and the sensor might not be able to find enough photons to make an image. To prevent these problems, most cameras use wider apertures in dim light.

The aperture also changes the aesthetics of the image by altering the depth of field or depth of focus – how much of the image appears sharp. Wide apertures force *selective focus* effects, putting only one part of the image in focus to concentrate the viewer's attention there.

Lens apertures are usually measured as f-stops, which technically speaking is the focal length divided by the diameter of the apparent aperture (how big the aperture looks when you peer through the lens, not its actual physical size). Standard f-stops follow the odd series (from largest to smallest) 1.4, 2.0, 2.8, 4.0, 5.6, 8.0, 11.0, 16.0, 22, 32. Each step larger cuts the light getting through in half (ie the smaller the f-stop number, the larger the aperture).

Lenses usually are described by their maximum aperture, which is the smallest f-stop number. Zoom lenses often bear two f-stops, for example f/2.8–4.3, because their largest aperture varies with the focal length setting of the lens. A smaller f-stop number indicates a lens that works in dimmer light, but lenses with larger apertures are often physically larger and heavier.

A wide aperture allows a lens to collect more light so you can take photographs indoors and at night.

Wide apertures limit depth-of-focus, forcing the viewer's attention on the in-focus part of the image.

Lenses of better digital cameras allow you to specify the f-stop setting for photographic effects.

Small apertures yield great depth-of-focus. Everything is sharp. You might not even need to focus the lens at all.

# PART  Zoom

A *zoom* lens lets you change its focal length at will. With a simple adjustment – a press of a button or twist of the lens – you can go from wide-angle to telephoto. In effect, you can step closer or farther from your subject without lifting your feet. That's great if you're standing on the edge of a precipice but useful even when all you want is the best photo.

A zoom lets you frame your image. You choose what to include and what to cut off. Although you can crop images after you've taken them, you'll get better quality using a zoom lens to frame your subject because you won't have to throw away any of the pixels you've paid for.

Zoom makes any camera more versatile. You can switch from wide-angle for snapping a shot of a choir to a close-up portrait of a single participant in seconds.

## Zoom range

*Zoom range* describes the difference between the widest and most telephoto abilities of a lens, expressed either in a range of focal lengths (for example, 35mm to 105mm) or as an 'x' factor. The 'x' represents the longest focal length of the zoom lens divided by its shortest focal length. For example, a 50mm to 150mm zoom lens is described as a 3x zoom.

For their versatility, zoom lenses trade-off the complication of needing many more elements, which makes them more costly. The greater the zoom range, the more complex and expensive lenses must be.

Although film photographers once sneered at zoom lenses, particularly those with wide zoom ranges, those for today's digital cameras are matched to the resolution of the image sensors. Inexpensive digital cameras make do with 2x to 3x zooms while the best may range to 10x.

Camera makers often state two zoom ranges, optical and digital.

The camera lens pops out of the body when switched on and extends further when the zoom is used.

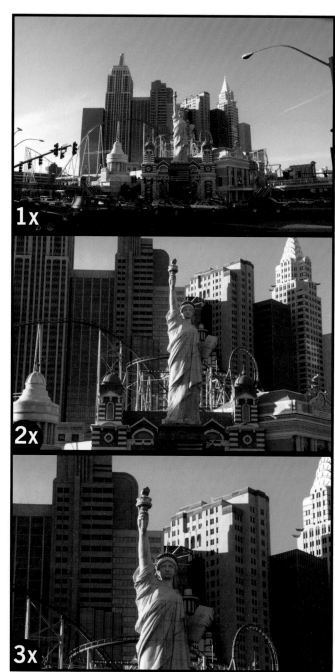

1x

2x

3x

## Optical zooming

Optical zooming changes the formula of the lens to alter its focal length. One or more additional lens elements move and, as they do so, they enlarge or shrink the image. No matter the effective focal length, the image fills every pixel of the image sensor.

The optical zoom occurs before the camera captures the image, and the image resolution remains the same whether you zoom in or out or not at all. In addition, optical zooming is continuous. You can take a picture at the minimum or maximum focal length or anything in between. The quality – meaning the sharpness, contrast and colour saturation – of the image produced by a modern zoom lens does not change as you zoom through the entire range of the lens.

Maintaining the quality of the image produced by a lens throughout its zoom range has always been a challenge for optical designers. Thanks to modern computers, however, they have become adept at creating superb zoom lenses. The designs are complex, however, and that means that they can be costly to produce. That's why you find the lenses with the most range only on more expensive cameras.

This shows the effect of using a zoom to tighten up a composition.

## Digital zooming

Digital zooming alters the image after it is captured by the camera. In effect, digital zooming enlarges the centre of the image to fill the entire frame. As with optical zooming, digital zoom makes small objects fill more of the frame. But to do so, it throws away the information from the pixels in the periphery of the image, wasting the resolution for which you paid dearly. In addition, you can usually zoom digitally only in discrete increments – for example, 1x or 2x but nothing in between.

You can create the same effect as digital zooming with image editing software as simple as cropping and re-sampling the original image (interpolating the smaller image back to the resolution of the original). The only advantage to digital zooming is that it enlarges the viewfinder image, which may be helpful in composing your shots.

Sometimes, camera makers add together the optical and digital zooming power of a camera to come up with a single, often large, zoom ratio. Don't be misled – the optical zoom is the one that really counts in image-making.

## Controls

Cameras usually offer one of two ways of controlling camera zoom, mechanical and electronic.

Mechanical control lets you directly adjust lens elements by extending the lens, usually by twisting a ring around the lens barrel. Mechanical zoom can be as fast as you are, and you can quickly find the exact setting you want.

Electronic zoom control gives you two pushbuttons, one to move the length towards wide-angle photography, one to move it to telephoto. A motor inside the lens adjusts its elements. Electronic control works well in video cameras because it gives a smoother zoom effect, but impatient photographers may not want to wait for the motor to run its range. Some cameras allow you to remote control their electronic zoom, which you cannot do with a mechanical zoom.

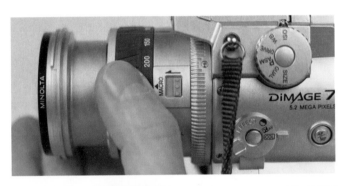

Mechanical zoom, top, is as fast as your fingers on the zoom ring. Elecronic zoom control, bottom, is pushbutton easy but may not be fast enough for grabbing quick shots.

# PART 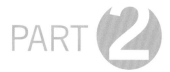 Shutters

The shutter in a digital camera adjusts the time during which the image sensor collects the light from the lens. In doing its job, the shutter has two effects on the pictures you take. By helping control the overall amount of light collected by the sensor (along with the lens aperture), the shutter helps determine the brightness of the image. Shutters can also freeze action. Images often move or change over time, even in a fraction of a second – people blink, horses gallop, racecars race, grass grows and paint peels. By limiting the time during which light is gathered, the shutter can capture a small slice of the image during which movement is minimal, even invisible. A fast shutter can simply stop motion – more correctly, the blurring effects of motion on captured images.

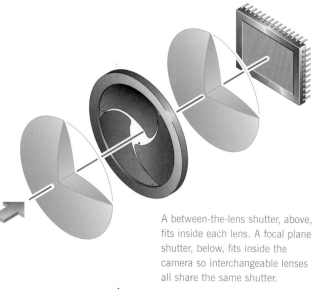

A between-the-lens shutter, above, fits inside each lens. A focal plane shutter, below, fits inside the camera so interchangeable lenses all share the same shutter.

Digital cameras may use mechanical or electronic shutters. Some use both.

## Mechanical shutters

A mechanical shutter stops light from striking the image sensor with an opaque physical barrier. The shutter opens, removing the barrier, for the duration of the exposure. An electronic timer in the camera controls the shutter speed.

Mechanical shutters have a secondary protective function. They prevent bright light from damaging the image sensors should, for example, you leave your camera pointed at the sun for an extended period.

**Between-the-lens shutters** fit inside the lens, usually between the front and back elements, most desirably near the aperture iris. Rather than a single piece, the shutter comprises several blades that move apart to let light pass through the lens then close again.

**Focal-plane shutters** lie almost against the image sensor near the focal plane of the lens (hence the name). Typically the focal-plane shutter has two light-blocking curtains that move in tandem across the image sensor with a small gap between them. The curtains travel at a fixed speed, and the width of the gap determines the effective exposure time. Focal-plane shutters are preferred for interchangeable-lens cameras because only a single shutter in the camera serves all lenses.

## Electronic shutters

An electronic shutter limits the time over which the image sensor is sampled to make an exposure. The camera simply collects light information for the period set for the shutter speed of the electronic shutter. Electronic shutters are fast and reliable but supply no protective function.

## Shutter speeds

Shutter speeds are measured in fractions of a second, with each faster speed roughly half the length of the preceding speed. Better cameras offer a wider range of shutter speeds. Stopping action requires speeds of 1/500th second and higher, with the need for speed increasing the closer you get to your subject and the faster it moves across your field of view.

When shutter speeds get slow, camera movement can blur photos, making them look out of focus. No matter how hard you try, you cannot hold a camera absolutely still. A good rule of thumb is that camera movement becomes evident when you hand-hold a camera and use a shutter speed of 1/30th to 1/60th second with a normal lens. Sharp photos with telephoto lenses require shorter exposures.

Most digital cameras set their shutter speeds automatically based on the brightness of the scene using a computer program that also controls lens aperture. Cameras that give you a choice of the exposure program – for example, those offering a setting for action photos – adjust the program to use faster shutter speeds for the action photos.

## Shutter lag

All cameras delay slightly between the instant you press the shutter release and when the shutter opens to make the exposure. With film cameras, the delay was purely mechanical. Digital cameras may impose further delays because of the time needed to set up their circuits for image capture. Some photographers have difficulty capturing the right moment in an action shot with a long shutter lag. With digital cameras this can be a major problem because some models delay several times as long as film cameras. In general, more expensive digital cameras impose shorter shutter lags.

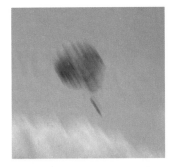

A high shutter speed can freeze action and prevent camera shake from blurring your photos.

The shutter lag of some digital cameras may make you miss the critical moment that makes a photo work.

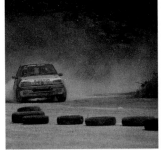

A fast shutter speed and continuous frame shooting is needed to capture action sequences like this

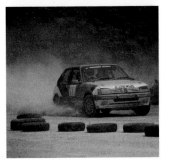

### RELATED SHUTTER ISSUES

**Shooting speed** An issue related to shutter speed is the shooting speed of a digital camera, how many frames you can snap in a second. You'll want a high shooting speed if you want to take action photos of sporting events. The same issues that impose shutter lag also constrain shooting speed.

Typical digital cameras shoot between one and three frames per second. Professional models may shoot ten frames per second.

**Flash recycling time** – the period required by a camera's flash to recharge between shots – can really slow things down when you're shooting indoors (or have the flash active outdoors). Some cameras may refuse to operate until the flash has recycled.

**Burst depth** Related to shooting speed is burst depth, the number of exposures a digital camera can actually collect in a fast sequence. The amount of buffer memory for temporarily storing images before they can be written to the slower memory of a memory card determines the burst depth. Cameras with small buffers can shoot quickly but only for a few frames. Capturing fast action sequences requires a big buffer. Some professional cameras, such as the Nikon D1H, can capture bursts of 40 frames.

# PART ② Exposure metering

For a proper exposure – which means for your pictures to have the optimum range of tones from white to black – your digital camera must adjust itself to suit the brightness of the lighting of the scenes you photograph. The camera must be able to measure this brightness, an ability called light metering or exposure metering.

Multi segment metering compensates for the lighting in common photographic situations (such as a backlit portrait) to get the proper exposure.

The camera must be able to measure the brightness of the scene. For a digital camera, that's easy. Its image sensor electronically measures brightness at every pixel in the image. But the camera cannot set a million different exposures. It must somehow develop a single brightness value from the millions of pixels and use that value to adjust the exposure.

To set one value, a digital camera could use any of an almost unlimited variety of combinations: it could add together all the pixels, look at only the brightest of them, average the brightest and darkest area, measure only the centre, and so on – and on. Although almost any strategy results in an image, often acceptable, none will always produce the best possible image. Finding a way of evaluating image brightness in the greatest number of situations has challenged camera designers since they first glued selenium cells on the fronts of their products.

Today's digital cameras often have multiple metering modes to allow you to select how it measures each scene. The most advanced cameras use matrix metering that gets the best exposure nearly 99% of the time.

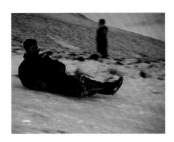

Fullscreen meters fail when the overall bright or dark scene shows as an average grey.

A fullscreen sensor measures light over nearly the entire image frame.

A spot meter measures only a small portion of the overall image.

## Fullscreen

Fullscreen metering integrates the illumination of the entire scene to come up with a single exposure value. It averages the measurements of all the pixels in the image sensor.

Fullscreen metering works because on average, the average scene has average illumination and brightness. That is, most of the scenes that you want to photograph have about the same relative range of brightnesses, even though the absolute brightness may vary.

To the camera, the brightness of the typical scene, when completely averaged out, works out to be a medium grey, right in the middle between white and black. But this greying assumption fails when most of the scene you want to photograph is lighter or darker than grey – for example, a skiier on a snowy white mountainside or a distant face in the night. The fullscreen metering system still interprets the overall scene as grey and misjudges the predominantly white scene and renders it too dark, making it grey (or, as is usually the case in snowy scenes, blue). It misjudges the black of night and makes it grey, too. The overall character of the image gets lost.

## Multi segment

The most advanced form of pattern metering uses computer-based intelligence to deduce what you're trying to photograph – not quite a canned aesthetic sense but no more than a step away. Instead of a single metering single spot, the digital camera evaluates the image in several (or several dozen) areas across the sensor to create a pattern or matrix. The camera then compares the pattern to those stored in memory. When it finds a match, it sets the exposure to the settings the camera maker has previously programmed to represent the optimal exposure for scenes that produce that pattern.

For example, a scene that's bright around the edges but dark in the centre might indicate a backlit subject, perhaps a portrait of someone with the sun behind. After the camera identifies the photographic situation, it adjusts the exposure by a stop or two so the backlit subject is not silhouetted.

Digital cameras differ in the number of segments in the matrix (more is usually better) and the adjustments made for each pattern. Although each camera maker uses its own scheme, all yield good results.

Each of these five areas of this matrix can measure the light and calculate the overall exposure required.

## Spot

If you're interested in only a small part of a scene, then it makes sense to meter only that small part and get it properly exposed. That's the idea behind spot metering – to measure the small spot in the scene where your chief interest lies. For example, meter only the skiier and not the mountainside, and the skiier will be properly exposed. More than that, the rest of the mountain will probably come out right, too.

Spot metering would seem to be the perfect solution to exposure problems, but it raises its own issues and questions. The chief one is 'Which spot?' The camera has no idea what part of an image is important to you, so it has no idea what to measure. (In truth, the camera has no idea at all about anything, but that's another story.)

Better digital cameras let you pick the spot, lock the exposure (usually by holding down the shutter release), then recompose the photo and snap the shutter using the locked exposure. Although this strategy works well, it makes the point-and-shoot process so complex that most people don't bother with it.

With spot metering, you must measure, lock the exposure and recompose each shot.

PART **2** DIGITAL CAMERA TECHNOLOGY
# Exposure control

Metering only creates information. What your digital
camera does with it is another matter. It can either sort it
out for itself or leave it for you to deal with. In other
words, automatic or manual exposure control.

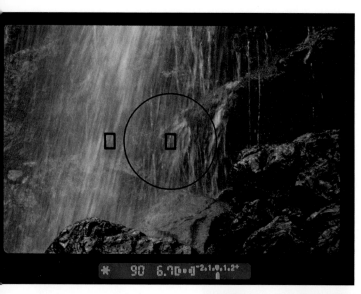

Many advanced cameras show
exposure values through the
viewfinder.

Automatic exposure control may
offer you several modes, illustrated
here by icons for settings, to
match various photo situations.

Exposure compensation settings
allow you to adjust for situations
that would confuse your camera's
auto-exposure system.

## Manual

Manual exposure is the old-fashioned way. The camera shows you
(usually in the view finder or on its control panel) the brightness it
measures for the scene, often as recommended settings of
aperture and shutter speed. You are left to exercise your
judgement – based on your experience of photographing similar
scenes – in manually adjusting the aperture and shutter speed.

Manual control lets you compensate for scenes beyond the
automatic range of your camera – sunrises, bright lights or
special effects. You can also control the depth-of-field of your
photographs, the amount of blurring from image movement and
similar aesthetic pictorial features. If you have the least pretense
towards making artistic photographs, you'll want a camera that
allows you to step backwards to manual exposure control.

## Automatic

Automatic exposure is not a single miracle, it's several.
Autoexposure systems may operate in any of three distinct modes
and may even allow you to choose which to use. These modes
include:

**Aperture priority** which asks you to set the lens aperture and
automatically adjusts the shutter speed for proper exposure;
**Shutter priority** which asks you to set the shutter speed, and the
camera automatically adjusts the aperture for proper exposure;
**Programmed** which asks only that you point the camera in the
general direction of what you want to photograph, and the
camera adjusts both shutter speed and lens aperture according to
a stored program.

The programs used by programmed exposure systems vary at
the discretion of the camera manufacturer. Some favour shorter
exposures to lessen the chance of blurring with long lenses.
Some favour smaller apertures to yield more depth of field to
simplify the job of autofocus systems. More expensive cameras
allow you to select from different programs to match the
photographic situation you face. Some cameras even let you
tailor your own programs or select from more exotic programs
stored on removable memory cards. We'll look at using these
modes later on (see page 62).

## Compensation

The compromise between automatic and manual exposure is to
handle things automatically but give you a veto. That is, let the
camera find its own way but to allow you to take over when things
get too challenging. Even low-end digital cameras have
rudimentary exposure compensation for brightening backlit scenes.

# White balance

All light is not the same. A sunset has a rich, orange feel to it, while cloudy days are definitely blue, but your eye sees colours the same because it automatically compensates for the changes in lighting. Such compensation is a challenge for a digital camera. It must determine what colour of light is present, then compensate for it.

Some digital cameras give you manual control of the white balance based on common types of lighting.

Automatic white balancing may unfavourably change the mood of some situations with unusual lighting, such as sunsets.

The colour of light is measured as its temperature expressed in degrees Kelvin (degrees Celsius above absolute zero). Ordinary incandescent light bulbs produce light ranging from 2,700° to 3,400° Kelvin. Direct sunlight is about 5,500° Kelvin, and cloudy days lit more by the sky than the sun range all the way up to 10,000° Kelvin. Take a picture with the camera adjusted for the wrong colour temperature, and it will assume an unnatural cast – orange if the scene lighting is cooler than the camera's setting, blue if it is hotter.

A digital camera adjusts for different colour temperatures through a process called white balancing. It adjusts the balance between colours so a pure white has no colour cast to it.
**Automatic white balancing** means that a digital camera can determine the proper setting itself. The camera analyses the entire scene and compensates for any overall colour bias. Fully automatic white balancing can produce unwanted effects, however. For example, the rich red and orange hues of a sunset may turn flat white and grey.
**Manual white balancing** takes two forms. Some cameras give you the option of referencing to a white card or area in a scene to adjust white balance, which helps overcome some biases in the scene. Others let you select colour temperature from a control-panel menu, or give you a switch that lets you select specific kinds of lighting – outdoors, fluorescent and incandescent. Some may even have settings for special conditions like sunsets.

White balance compensates for colour casts caused by scene lighting. An orange cast (top) results when the colour temperature is lower than the correct white balance. A blue cast (bottom) results when the colour temperature is higher.

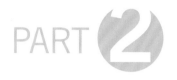

PART 2

DIGITAL CAMERA TECHNOLOGY

# Flash

No matter how sensitive a digital camera's image sensor, it cannot find an image in absolute darkness. To allow you to take photographs even when insufficient light is available, most digital cameras incorporate their own light source – a flash.

As light sources go, on-camera flashes are tiny. The effective range is typically three metres (ten feet). In a theatre, for example, they won't reach the stage even if you're no more than four rows back. If you need more light, you must use a more powerful flash.

To accommodate add-on flash units, better digital camera (usually prosumer and professional models) have either hot shoes or 'PC' connections. A hot shoe combines a mounting bracket for the external flash unit (the shoe) with electrical contacts (making it electrically 'hot').

Most built-in flash units use automatic exposure control. The flash is coupled to the exposure system in the camera. When the camera determines the flash has provided enough light, it switches the flash off. Although a single flash is brief, the camera can shorten it to one-tenth its maximum length and thus limit the light falling on a scene. Hot-shoe contacts often extend this automatic capability to external flash units.

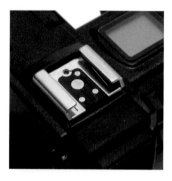

The hot-shoes of digital cameras that have them usually have multiple contacts to link the automatic controls of the camera to the flash.

A pop-up flash provides extra light when you need it but otherwise hides out of the way.

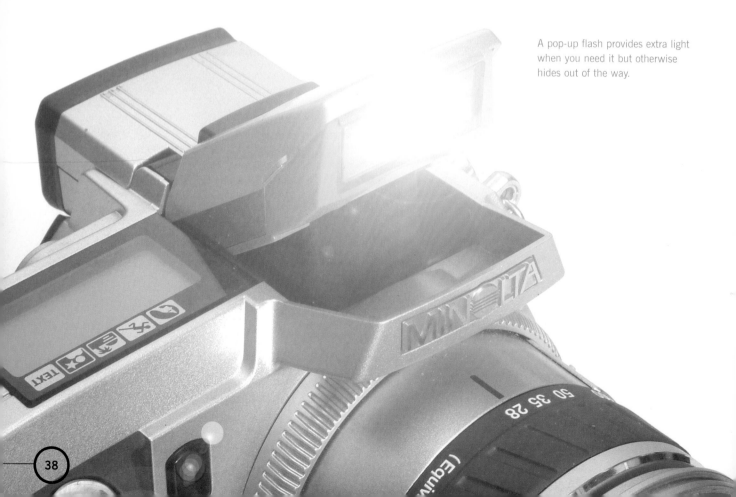

## Guide number

Some flashes are more powerful than others. The measure most often used to indicate flash power is the guide number. (Studio flash units use a more scientific measure, the watt-seconds of power used by the flash.) Although most on-camera flashes do not have guide-number ratings because they are meant solely for automatic control, auxiliary flash units meant to attach to better digital cameras are often rated by guide number.

In truth, the guide number of a flash is meant for calculating, not indicating power. From the guide number, you can determine the manual aperture setting of your camera for proper exposure using the flash.

Guide numbers depend on film speed, so you'll see them listed as something like 'Guide number 50 ISO100 film'. Although digital cameras don't use film, most allow you to set their sensitivity to the equivalent of common film speeds.

To use the guide number, divide it by the distance in feet to the subject you want to photograph. The quotient is the aperture setting to use, expressed as an f-stop. With a guide number of 50 and a subject 8 feet from the flash, you would need to use an f-stop of 6.25. The closest standard stop is f/5.6, to which you would set your camera.

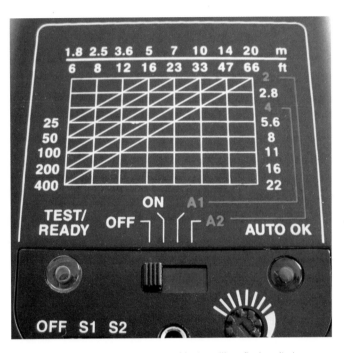

Most auxiliary flash units have manual controls to adjust their power by guide number of f/stop setting.

Red-eye results from a flash reflecting from inside the eye but can be minimised using the red-eye reduction settings on most digital cameras.

## Red-eye reduction

With old or inexpensive cameras, taking a flash picture of a normal human being is likely to turn your subject into a fiend, one with glowing red eyes. The flash, being located close to the camera lens, bounces directly off the retina of the subject and into the camera lens. Lush with blood, the retina appears red, and the flash illumination makes it appear to glow (at least to the camera). It's a great effect for Hallowe'en photos, but not one that endears grandma to the children.

Clever camera designers came up with a way to sidestep the red-eye problem. They programme their cameras to give two flashes for each exposure. The first flash causes the pupils of your subject's eyes to contract, as it would in any bright light. After an appropriate delay to let the pupil close, the flash goes off again to make the actual exposure. The narrowed pupil lessens or eliminates the red-eye effect.

Of course, red-eye reduction is of no help when taking formal portraits where normal pupils contribute to the aesthetic nature of the picture. Professional photographers avoid red-eye by keeping their flash units far from the camera lens so the flash does not reflect from the retina. They need no preliminary flash, so they capture the subject's pupils in their natural state.

Many digital cameras include red-eye reduction. Some allow you to switch it on and off as a special feature. Look for it if it is important to you. But remember, red-eye is easily edited away with your photo editing software, see page 116.

DIGITAL CAMERA TECHNOLOGY

# Focusing

The correct focus of a lens is one of those things that's easy to see and hard to explain. Focusing makes photos sharp, but achieving proper focus requires adjusting the distances between the subject, lens and image sensor to exactly the right relationship. It can be one of the critical skills of photography – and often one of the most difficult for amateur and pro alike.

Passive autofocus systems work like you, targeting a high-contrast subject and adjusting itself for greatest sharpness.

## Autofocus

A good autofocus system is more accurate than most people at adjusting the focus of a camera, and often faster. Autofocus systems are either passive or active. Each has its advantages and shortcomings. Digital cameras may use one, the other, or both.

**Passive systems** look at a scene and attempt to work out what the correct focus is. They operate like a photographer, by looking at edges and lines and adjusting the focus until they are as sharp as they can be. Passive systems require sufficient light so that the camera can see enough contrast to distinguish sharp edges, although some passive systems get a boost by supplying their own invisible infrared illumination when necessary. They also require a suitable subject – one with something they can focus on – and may fail on subjects with subtle contrast. On the other hand, passive systems are rarely fooled by intervening windows.

**Active systems** work like radar or sonar. They send out a signal, usually infrared (though sometimes ultrasonic), watch for its reflections and judge from the time elapsed between transmission and reception how far the signal travelled. Active systems work in any kind of light (because they supply their own) but can mistake the reflection from a window for your subject. Active systems have a limited range, which is no problem for normal lenses (out-of-range translates into infinity focus) but sometimes may run out of range with long telephoto lenses.

## Fixed focus

Fixed focus is no focusing at all. It creates a sharp image at only one distance to its subject because the distance between the lens and image sensor is fixed; locked into the design of the camera. Everything else (and often just plain everything) is out of focus. Although this situation would seem highly undesirable and even unacceptable in a camera, fixed focus often works and is popular (because it's cheap) in inexpensive point-and-shoot digital cameras.

Fixed focus works best when its shortcomings are hidden by other shortcomings in the camera system. If a lens never produces a truly sharp image, you'll never be able to tell when it is out of focus. If the camera has low resolution, the lack of lens sharpness will never be apparent.

The fixed focus system takes advantage of another optical property. Wider angle lenses make focusing less critical, consequently most fixed focus lenses are a bit wider than 'normal'. They work well for group portraits. As long as you don't more than moderately magnify the image made by a fixed focus lens – for example, no more than to snapshots – you won't notice the focus deficiencies.

## Steps

Inexpensive autofocus systems for cameras don't always bring all subjects into absolute focus. Rather, they have stepped focus systems that adjust the lens to accommodate a range of distances from the subject. Some digital cameras (particularly point-and-shoot models) may have as few as three focus ranges, or steps, and hide the shortcomings much as do fixed-focus cameras.

*Stepless autofocusing* zeroes in on the proper focus without discrete steps. All better digital cameras work this way.

## Focus lock

Autofocus systems need to know what subject you want to focus on. Most look at the central part of the image and focus there. To accommodate subjects that are not in the centre of the image, most cameras provide a focus lock that makes autofocus a five-step process:
Centre your subject.
Let the camera focus.
Lock the focus (usually by pressing the shutter halfway down).
Recompose your photo.
Release the shutter.

Cameras with stepped autofocus systems may have as few as three focus ranges corresponding to the distances for portrait, small groups and landscape photographs

Manual focus controls take two basic forms, a ring around the lens (below) which operates like those on old film cameras or (above) a thumbwheel more conveniently located elsewhere on the camera.

## Manual focusing

When you want to be creative, or when conditions cause your camera's autofocus system to fail, you should be able to take manual control and focus conventionally. Digital cameras differ in how easily (and whether) you can use manual focus. Some let you focus with a ring around the lens like conventional manual-focusing lenses. Others add special knobs or thumbwheels on the camera, or give you pushbutton control.

If you plan to use manual focusing often (you may have no need if all you want is occasional snapshots), look for a camera that makes manual focusing easy and puts the controls where they are readily accessible.

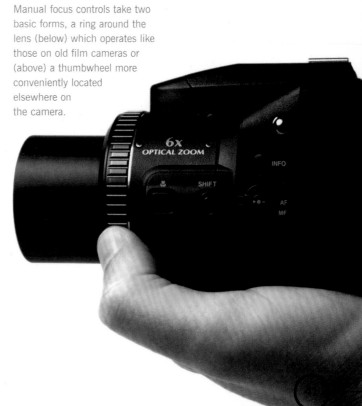

# PART 2 Viewfinders

The viewfinder is named after its function: it helps you find the view that you want to photograph. On still cameras, a viewfinder can be as simple as a frame that works like a gun sight or as complex an optical system as the Hubble Space Telescope. The viewfinders on most of today's digital cameras give you a direct preview of exactly (or nearly) the image the camera will capture. But designers can select from many kinds of viewfinders. You should match the viewfinder on the camera to the way you want to work. Critical or professional work requires a through-the-lens viewfinder, but shooting snapshots can make do with a simple optical viewfinder.

The frame marks in a viewfinder are usually slighly offset to compensate for the position of the lens and reduce parallax error.

## Simple optical viewfinder

A simple optical viewfinder is actually a small telescope mounted in your camera that simulates what your camera's lens might see. The optical viewfinder is sometimes called a bright viewfinder because its independent optical system yields bright view even in dim light. Often viewfinders show more than the camera lens sees but superimpose framing marks to show the limits of what the camera will capture.

The viewfinder shows your subject through an entirely different optical path from that of the camera lens (which means, apart from anything else, that it won't warn you if your finger or camera strap is in front of the lens as you take the picture!). The optical effect caused by the difference between these two viewpoints – finder and lens – is known as parallax, and with close-up shots parallax is at its most evident and can cause you to miss your subject entirely unless you make allowance for it. Only inexpensive point-and-shoot cameras have simple optical viewfinders.

## Sports viewfinder

A sports viewfinder is nothing but a wire frame you look through to imagine the edges of your photo. It's quick and, because you can see beyond all edges of the frame, you can easily follow all of the action. It's also the least accurate of viewfinders.

## Coupled optical viewfinder

A coupled optical viewfinder also uses an independent optical system but it is linked (or coupled) with the zooming system of the camera lens so the two track and you get the same view as the camera lens no matter what the zoom setting is.

To make what your eye sees through the viewfinder as close as possible to what your lens sees, more sophisticated viewfinders have built into them something called parallax compensation (see left). As you focus on close subjects, the parallax correction moves the bright-line frame in the viewfinder to more closely correspond to what the camera lens sees.

## Rangefinder

A rangefinder, strictly speaking, doesn't give you a view. It only tells you the distance to an object. A coupled rangefinder is connected to the focus of the camera lens so that as you adjust it to the proper range, it automatically sets the focus distance on the lens through a mechanical linkage. Rangefinders are unnecessary (at least camera makers think so) on modern autofocus cameras – the camera is faster and more accurate than you are, so camera makers don't bother with expensive mechanical systems.

## Through-the-lens viewfinder

A through-the-lens viewfinder uses a special optical system that lets you frame and focus your image using a view though the camera's main lens. You see exactly what the camera sees no matter how you zoom or how close you move to your subject.

Most through-the-lens viewfinders are called reflex viewfinders because the light reflects off a mirror or prism on the way to your eye to compensate for the camera lens inverting the image.

The common single-lens reflex (SLR) camera uses a mirror to reflect the light from the camera lens into the viewfinder system, snapping the mirror out of the light-path during the exposure and producing the characteristic sound of the SLR. Most professional digital cameras use this design. Another technique is to use a pellicle mirror, one that is partially reflective, to divide light between the viewfinder and image sensor.

## Electronic viewfinder (EVF)

An electronic viewfinder (EVF) is actually a small video monitor disguised in a digital camera to look like an optical viewfinder. The image in the EVF comes from the camera's image sensor, so you get a true through-the-lens preview, but the video image is not as sharp as that of an optical viewfinder, and focusing is less easy – however, autofocusing systems make this issue moot. Some electronic viewfinders shift to black-and-white viewing in dim conditions so you can still preview the framing of your photos.

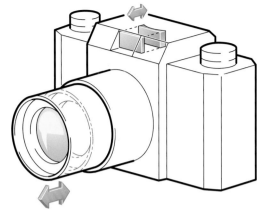

Most consumer cameras have a viewfinder separate from the main lens. Coupled optical veiwfinders are connected to the zoom mechanism so you see what the lens sees.

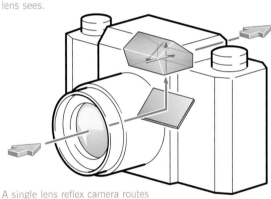

A single lens reflex camera routes light to your eye with a mirror to preview images, then snaps the mirror out of the way to actually take the picture.

### GLASSES AND VIEWFINDERS

The typical viewfinder is designed to make its image appear as if it were about one metre (roughly three feet) from your eye. As a result, both near- and far-sighted photographers may need to resort to wearing their glasses to focus properly. Glasses, however, force the photographer's eye away from the viewfinder so that seeing the entire image may be impossible. Moreover, when the photographers move in to get the best look, they can scratch the lenses of their glasses and push them into their face.

To cope with these problems, camera designers have come up with two primary solutions:

**High eye-point viewfinders** let you see the full image farther from the viewfinder, giving those who wear glasses a better look. Although a welcome relief, such viewfinders are but a partial solution and do nothing to prevent damage to your glasses.

**Diopter adjustment** adds a corrective lens that works like your glasses to let you focus your camera without wearing your glasses. Some digital cameras offer integral diopter adjustment – a small control you turn or slide to adjust the diopter correction – or may rely on supplemental lenses. The range of built-in diopter adjustments is often limited, typically to –3 to +3 diopters. Check your glasses prescription to be sure that any camera you consider has sufficient range to control your vision problem.

A digital camera viewfinder often presents more information than just the image, including exposure settings, frame number, even the resolution of the image.

DIGITAL CAMERA TECHNOLOGY

# View panels

The view panels that are de rigueur on all but the least expensive point-and-shoot digital cameras serve two purposes. They allow you to review the images that you've captured. In addition, they can let you preview the image before you capture it, acting as a supplemental viewfinder. Today the view panels on digital cameras universally use Liquid Crystal Displays or LCD to preview images. These LCD panels are much like those on notebook computers, only smaller and brighter, and able to cope with daylight without washing out.

## Size

A bigger picture is better, within reason, and the same goes for LCD panels. The bigger the panel, the more you can see. And, of course, the bigger the panel the more it costs and the more power it's likely to devour. The range in size is modest, from about 4cm to 5cm, but important when you want to access detail or review thumbnail images.

How big a screen you need is a matter of personal judgement and taste. A small screen is better than none, but when you use your screen for image management with a multi-shot display, you'll want something larger.

## Pixels and dots

The resolution of on-camera LCD panels is substantially lower than computer monitors, typically about 200,000 pixels. Camera makers can get away with that because the image is sufficiently small for you not to discern the individual pixels even at such a low resolution. Moreover, the function of the screen – previewing or reviewing of the images – doesn't demand anything larger or sharper. After all, it's nothing you're going to pass around to let everyone see.

However, an LCD panel with more pixels is better as it will make it easier for you to judge the image you are taking or have taken.

← 600 pixels →

↕ 400 pixels

Viewscreens have lower resolution than the images the camera takes, but they are sufficient for previewing small images.

## Frames per second

Even though you may plan to use your digital camera solely to take still photographs, you need to be concerned about the moving image in the viewfinder and its frame rate. As with all video systems (and the viewfinder is actually just a dedicated video system), the frame rate determines how natural movements look on the screen. If the screen does not update fast enough, the jerkiness of the image may make framing the scene more difficult. You might even lose that critical moment you want to photograph between screen updates. Although the standard video rate of 25 frames per second is best, even half that rate is sufficient for previewing most scenes.

## ADJUSTABILITY

If you plan only to use your LCD panel to review images, you don't much care about where it is on your camera. You can just tilt the camera to the viewing angle you prefer. If, however, you want to use the panel as a viewfinder, the mounting of the LCD is decidedly important. It must be located so you can view it conveniently while pointing the camera lens at your subject. Some cameras let you swivel the panel independently from pointing the lens. An adjustable view panel lets you use it like a waist-level viewfinder or view camera's ground-glass screen.

# PART  Playback modes

In framing a shot, the only image display you'll want is a full screen view of what your camera sees. But when you review the photos that you've taken, for example to edit out bad shots to free up memory, you'll want a camera with additional viewing modes.

## Single image
What you see is what you got is the basic function of the viewfinder in review mode. In single image mode, that's all you see – a one-shot view. Most cameras will let you sort through all of the images that you've exposed so that you can look at them one at a time. Although you can't compare shots (except in your mind), you will see the greatest possible level of detail.

## Multiple image
In multiple-image mode – sometimes called thumbnail mode – your camera breaks its viewfinder into a matrix of individual images, typically an array of four or nine. Although each image is a fraction of its individual size (say one-quarter or one-ninth), this mode allows you to make side-by-side comparisons. You can pick out an image to keep or trash in one quick glance. This mode is particularly useful when you urgently need more memory and want to eliminate wasted shots to gain memory space. It also helps you locate an individual image from a selection with speed.

## Slide show
Slide show mode gives you a one-after-another display of the images in a digital camera's memory. This mode allows you to briefly view all the photos you've captured before deciding to chuck them and start all over again.

### ZOOM MODE
The small screen and low pixel count in digital camera LCDs can make checking image details difficult. Consequently many cameras incorporate an electronic zoom mode in their viewfinder systems. Typically this mode will let the LCD panel display one pixel for each pixel in the captured image, which magnifies the image by a factor of two to four. Although you cannot see the entire image at one time, you can usually pan across its width and height to check each pixel. If you're critical about the images you take, you'll want zoom mode.

# PART  Image storage

The film used in chemical photography provides two discrete functions. Not only does it sense and capture the original image, it is also a storage system for the image. Although the image sensor in a digital camera captures images, it cannot save them. Preserving its images requires memory or storage.

Digital cameras store images either in internal memory or in removable cards. Because these cards provide the image-storage function of film, some manufacturers call them digital film.

Internal storage has its limitations – chiefly the very fact that it is limited. It allows the camera to hold a dozen or so images. Once it's full, you have to discard or download before you can take more.

Card-based storage allows you to slide in a fresh card to replace once that's full of images. You can then download the images into your computer (or print them directly) at your convenience and wipe the card clean. Over the years, manufacturers have developed a multitude of card formats.

## CompactFlash

CompactFlash, developed in 1994, is the oldest and the most versatile of digital camera storage standards. It features large capacities, currently up to one gigabyte per card, as well as the ability to host microdrives, miniaturised hard disk drives that can also store about a gigabyte of images.

In design, a CompactFlash card is itself a miniaturised version of the PC cards that slide into notebook computers. As a result, a simple adapter serves to let you plug a CompactFlash card into a PC Card slot. CompactFlash cards measure 43mm x 36mm x 3.3mm.

The chief shortcoming of CompactFlash is that the standard does not provide for security and copy-protection. This makes manufacturers shy from the design for music playback systems and allows anyone finding a lost card to view its contents. The CompactFlash standard is governed by the CompactFlash Association or CFA, which maintains a web-site at www.compactflash.org.

## SmartMedia

Once called the Solid State Floppy Disk Card or SSFDC, the SmartMedia card was originally designed to be the thinnest and smallest type of removable flash memory card. Measuring 45mm x 37mm x 0.76mm, a SmartMedia card looks like a chip of black plastic – and that's essentially what it is. It's simply a protective shell holding one or more Flash Memory chips.

The simple design makes SmartMedia inexpensive. Although new designs are now smaller than SmartMedia and nearly equal in simplicity (and cost), it remains popular with digital camera makers. Adapters are available to fit SmartMedia cards into notebook computer PC Card slots. Currently, however, CompactFlash cards can individually store more bytes and images. As with CompactFlash, SmartMedia has no security features. Its highest capacity is 128 megabytes.

## Memory Stick

Sony Corporation developed the Memory Stick package for universal storage that it could control as a proprietary system. The same stick fits digital cameras, digital video recorders, and MP3 players. Although once made only by Sony, the company have licensed other manufacturers to produce Memory Sticks. Notwithstanding Sony's efforts to make you believe the stick design is a breakthrough, nothing except the package distinguishes the basic technology from other memory cards.

Each Memory Stick resembles an old-fashioned stick of chewing gum, about 50mm long, 21.5mm wide and a bit more than 2.8mm thick. For applications demanding even smaller media, Sony offers the Memory Stick Duo, which measures 31mm x 20mm x 1.6mm. Currently capacity peaks at 128 megabytes.

The plastic package of each memory stick comes in one of two colours. The basic Memory Stick is blue and is meant for general-purpose storage. A white Memory Stick incorporates Sony's Magic Gate copy-management protocol. Sony maintains a website about the Memory Sticks at www.memorystick.com.

## MultiMedia cards

Several of the developers of CompactFlash developed MultiMedia cards (MMC) as a more compact storage medium, smaller than SmartMedia cards (at 24 x 37mm) but about twice as thick (at 1.4mm). The cards come in two types, ROM-based for pre-recorded music (digital cameras cannot store their images on ROM), and Flash memory for recording your own music and photos. Current cards store 64 megabytes. Despite being backed by an organisation with over 100 members, the MultiMedia Card Association, (website: www.mmca.org) MultiMedia cards haven't won a great following among digital camera makers.

A 64MB MultiMedia card      A 128MB XD picture card

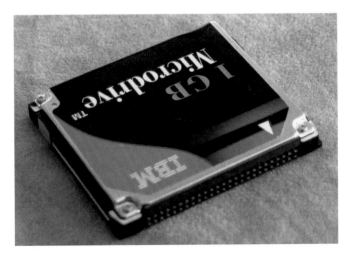

IBM's 1Gb microdrive.

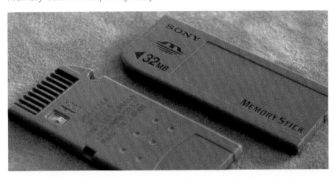

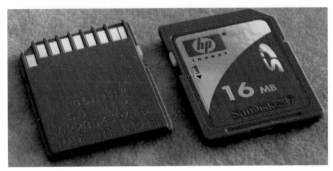

A 16MB Secure Digital card

## Secure Digital

Derived from the MultiMedia Card, you can consider the Secure Digital to be MMC with copy protection. The Secure Digital design is an obvious rethinking of the MultiMedia Card concept. The same size as the older design, Secure Digital differs only in having two more pins on its connector, an optional thicker format for more complex circuitry and a write-protect tab.

By sliding the tab up the side of the card, you can prevent compliant electronic gear from disturbing the contents of the card. The specification also allows for a read-only card without a sliding tab. The current card design accommodates capacities up to 256 megabytes.

## xD Picture Card

The latest player in the memory card game is the xD Picture Card, jointly developed by Olympus and Fuji Photo Film Company. The initials stand for 'extreme digital'. Now the smallest digital camera card, an xD Picture Card measures 20mm x 25mm x 1.7mm.

The card design allows for capacities up to eight gigabytes per card, but the largest capacity currently available is 128 megabytes. An adapter converts xD Picture Cards to fit the PC Card slots of notebook computers.

## IBM Microdrive

IBM developed the Microdrive for professional photographers who needed more space on card. This was at a time when you could only get 128Mb memory cards. Things have changed and now memory cards are catching up in capacity. The main reason to buy a Microdrive is it's more competitively priced, but it's also more fragile and won't survive heavy knocks.

# PART  **Connections**

Downloading images from a digital camera to your computer or printer requires some kind of connection. Among current digital cameras, four interfaces are popular – standard serial, USB, FireWire and infrared.

## Serial

The standard serial connection works with virtually any computer but is also the slowest connection in general use, peaking at a speed of 115,200 bits per second, a rate that may demand ten minutes to download the contents of a modest-size camera memory. (Macs can do better, having a serial interface that runs up to 921 kilobits per second.)

## USB

The USB (Universal Serial Bus) port design comes standard on all new computers and most cameras. It is both easier to use and faster than serial and should be your preferred connection. Two versions are now available: Version 1.0 operates at about 12 megabits per second – fast enough to empty a memory card in less than a minute. Version 2.0 operates at 480 megabits per second.

If your computer lacks a USB port, you can add one inexpensively (under £30). You also need Windows 98 or later to make it work.

## FireWire

The connector of choice for digital video systems, FireWire offers high-speed connections (100 to 400 megabits per second) and no-hassles connections. A few digital camera makers have adapted the FireWire connection to their products. Although standard on most late-model Macintosh computers, FireWire connections are rare on Windows computers and usually require you to install a FireWire port.

## IrDA

An infrared port, often called IrDA after the Infrared Data Association, which standardised the design, can connect your camera to your computer without wires at speeds up to four megabits per second. Your computer or printer needs a matching IrDA port. Unfortunately, most desktop computers and a growing number of notebook machines lack the ports and add-on IrDA ports have become difficult to find (check www.irda.org for suppliers). In other words, IrDA is a good choice only if you have a computer that also has a port.

## Video output

Most digital camera also have video outputs that let you use it as a video camera. With this connection, you can plug your digital camera into a monitor or videocassette recorder. Note, however, that the quality of image available through a video output is always lower (usually substantially so) than you get with a digital connection.

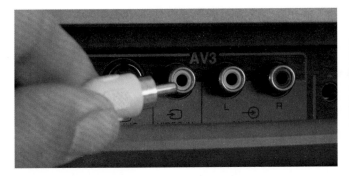 

## Composite video

The composite video signal is used by most video monitors and produces the lowest quality. Note that video standards differ across the world. UK systems use the PAL standard and digital cameras meant to be sold here use those signals. Cameras meant for Japan and America use a different standard (but the same connectors) called NTSC and will not work with UK video equipment. Be careful when you are offered a bargain camera from abroad, especially if you want to use its video connection.

## S-video

The 'S' in S-video stands for 'separate'. Where conventional composite video signals squeeze all three colours into one signal, S-video uses two – and gains higher quality in the bargain. You'll get better video from a digital camera with an S-video output, but your other equipment must be able to handle S-video as well. As with composite video, you'll also want to insure the S-video output of your digital camera is compatible with UK standards.

### WHAT TO LOOK FOR

Besides the obvious issues of speed and availability of matching port on your computer, you should consider some more subtle connection issues when looking for a new digital camera.

**Location**. Ensure that the location of the connectors doesn't interfere with the tethered operation of the camera. For example, you don't want the video cable to interfere with your finger on the shutter release.

**Security**. Make sure that the connections are snug and won't inadvertently loosen themselves. You don't want a plug to fall out in the middle of your work. Remember that with age all connectors get looser and less reliable. You don't want to start from a precarious position.

**Standardisation**. A connection system that uses standard cables should be preferred. Cables are apt to break or wear out, so you'll want to be able to readily replace them. If your camera uses a proprietary cable and its manufacturer discontinues the cable, your camera may become useless.

**Card reader**. A growing number of photo printers have built-in card slots so you can print your photos without downloading as easily as unplugging the memory card from your camera and sliding it into the printer. Be sure the card type (CompactFlash, SmartMedia, SecureDigital, etc.) recognised by your camera and printer match.

# PART 2 **Power**

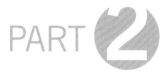

Digital cameras are electronic devices and consequently need a steady supply of electricity. That power has to come from somewhere, and the places of choice are two – from self-contained batteries or from utility-supplied electricity through an external transformer, the ubiquitous power brick.

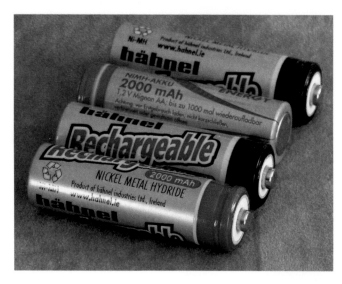

Alkaline cells are ordinary batteries of the sort you'd buy for a torch (flashlight). (Old-fashioned 'heavy-duty' carbon-zinc batteries can't supply enough current for most cameras.) The power demands of some cameras strain alkaline cells, and if you take a lot of pictures, their cost will strain your budget. Most digital camera makers now recommend alkaline cells only for testing and emergencies.

Rechargeable cells come in two types, nickel-cadmium (nicads) and nickel-metal hydride (NiMH). The latter store almost twice as much energy and last nearly twice as long, so your choice should be obvious. You'll also need a charger matched to the battery chemistry because each requires a specific charging rate.

External adapters reduce mains power down to battery level. Although they are impractical if you're shooting landscapes, they assure constant power during studio sessions; for example, if you're taking a lot of portraits. If you use a tripod or camera stand, the wire won't interfere.

## Batteries

Standard-size cells (including AA and AAA batteries) may use any of several technologies: carbon-zinc (standard and heavy-duty), alkaline, nickel-cadmium (Ni-cad), nickel-metal hydride (NiMH), and several kinds of lithium. Different battery manufacturers use different designs for their products even within a technology, which can influence the current they produce. To get the optimum life from cells, never mix brands – even brands that use the same technology.

Rechargeable cells have a finite life, up to 1,000 charge/recharge cycles, but often substantially fewer. Although camera makers often offer their own brand of cells for their products, you can replace them with other brands of battery that use the same technology, usually at substantial savings.

Most digital cameras use standard AA or AAA batteries, typically about four (the number needed to get enough voltage for conventional logic circuits). AA batteries have greater capacity but AAA cells are more compact and are used in the smallest digital cameras.

## Battery care

To get the longest life from rechargeable batteries, you must take proper care of them. Following a few simple rules will do the trick.

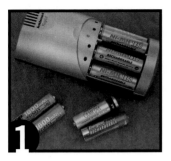

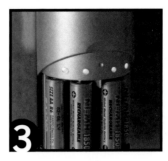

*You'll need at least two sets of batteries to properly care for them and keep your camera always ready.*

*Although battery makers claim current batteries have no memory effects, most recommend that you recharge only after fully discharging the cells. Which means, run your batteries into the ground. Use cells until they fail to operate your camera.*

*Always charge cells for the recommended period. To avoid self-discharge problems, leave cells in the charger until you need them (unless the battery-maker recommends otherwise).*

## AC power

Nearly all digital cameras make provisions for plugging in an AC adapter, an extra jack for a power connection. Many, however, make the AC adapter an option – usually an expensive option. You can often get a generic AC adapter for half the price the camera makers charge.

Be sure to match the voltage, current and polarity of any AC adapter you buy to your camera. This information should be in your camera's instruction manual. A mistake here can be fatal to your camera. (Many people bite the bullet and buy the expensive camera maker's AC adapter to avoid such worries.)

Most makers of AC adapters list the voltage, current and polarity of the output on the adapter itself.

### KNOW YOUR BATTERIES

**Rechargeable batteries** self-discharge. They lose power after charging even if you don't use them, as much as 10% of their capacity in a week. Most chargers are designed to keep batteries topped up as long as they are plugged in, so store your cells in their charger. Avoid removing rechargeables from the charger and storing them as spares.

**Alkaline cells** self-discharge slowly, a few per cent per year. That makes them a top choice for emergency spares. Keep a pack in your camera bag just in case – but use your rechargeables for everyday photography.

**Never try to recharge alkaline cells.** They may explode if you put them in a charger. Exception: Ray-o-vac 'Renewal' brand cells are meant to be recharged, but only in their own special charger.

**Special 1.5-volt lithium cells** will work in most digital cameras but are not a cost-effective choice. Stick with rechargeables for everyday work, alkalines for spares.

**The biggest power-users** in a digital camera are the LCD screen and flash. To extend battery life, minimise your use of each.

# PART 2 Physical considerations

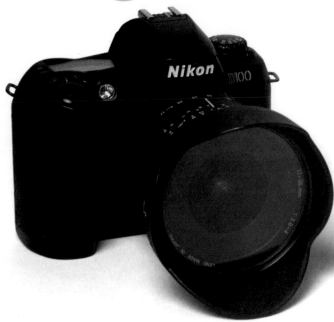

You can't ignore the physical entity of the camera itself. It's the real thing you can hold in your hands – and you have to hold it in your hands to use it, if just to screw it on a tripod. Indeed, the physical reality of the camera is something you'll grow to love or loathe regardless of the quality of the images it captures.

## Dimensions

Those advertising pictures that show your favourite camera choice suspended in air and surrounded by an angelic halo, mislead rather than inform. Out of context, you have no idea how big the camera really is and whether it will fit into your hands or require a trolley to carry about. Some supposedly compact digital cameras are bigger than you might think (studios choose models with big hands to make the camera look small). It's best to check the spec sheet before you make up your mind. Better still, wrap your hands around the camera you favour and be sure it's a good fit for your grip before a surprise of bulk turns your expected joy of ownership into an eternal gripe.

## Weight

Film cameras are filled with a lot of air to give room for film. That space need not be wasted in a digital camera, so compact models often are heavier than their conventional equivalents. Don't be surprised if the little thing weighs more than you expect or threatens to slice through your neck thanks to the thin, coarse strap the manufacturer supplies. If you plan to carry a digital camera around all day, put heavy consideration on its weight.

## Controls

The more expensive the digital camera, the more controls it's likely to have – so many that you're apt to find them scattered all over the camera. Once you enter the prosumer arena, it's unlikely you'll be able to work out for yourself what all these controls are for – the manual is a necessity (there's just so much you can do with the camera).

In choosing a camera, you need to ensure that you can reach and use all the controls conveniently – particularly those you use every day, including the shutter release, compensation controls, mode control and manual functions (if you plan to use them) such as focus, aperture and shutter speed. With more complex cameras, insure that you can work your way through the menuing system.

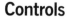

## Lens caps

Your camera's lens is one of its greatest vulnerabilities. Scratch it, and every photo you make thereafter will be blurred. Poke it with a finger, and your photos will have a soft, misty effect that will take a severe cleaning to change. A broken lens makes a dead camera.

Every camera should provide a protective cap for when its lens is not in use. Better point-and-shoot cameras build it in so you can't lose it. Opening the camera or the cap quite likely switches on the camera. This helps to prevent missed shots – all black when you leave the lens cap on.

As with film cameras, better digital cameras use removable caps. If you tend to leave newspapers and umbrellas behind when you leave the coffee shop, invest in a cap-trap, a stick-on string that holds the cap when you pop it from the lens. Or, take a tip from the pros and substitute a clear, skylight, or UVa filter for the cap and leave it in place. Shoot through the filter, and only remove it to clean it. (The best way is with a bit of detergent under running water.)

## Tripod mount

It's just a screw hole but a mighty important hole if you're serious about photography. Ensure your digital camera has a tripod-mounting hole so that you can firmly attach it to a support for long exposures, telephoto shots and using the self-timer. If you ever plan to join in a group photo, this last application makes a tripod mount mandatory even for simple point-and-shoot cameras. No serious camera is without one.

Note that two sizes are standard: a large tripod mount is popular in Europe while the Americans and Japanese use a small one. It's easy to adapt big to small – a bush will do – but going the other way is a problem. If you already have a tripod (or plan on buying one) ensure your camera and tripod match.

## Straps

You'll soon tire of carrying your camera wrapped in your fingers like a jewel stolen from a Buddhist idol. A strap gives you hands-free camera portability. Be sure your digital camera choice has lugs for attaching a strap.

The traditional around-the-neck camera strap keeps you ready for action, but may beat you to death during vigorous activities such as horseback riding or bicycling. Aftermarket strap systems hold your camera close to your chest without bouncing.

Inexpensive point-and-shoots may have only a single lug for a wrist-strap. Although these can be better than nothing (a wrist strap may save you from dropping your camera down a volcano or into the sea), they can be uncomfortable – the camera will bump your wrist and hand, and the strap will slowly saw through your arm.

A wide strap saves slicing off your shoulder when a skinny standard equipment strap digs in. They are inexpensive, colourful and can be customised. Although manufacturers haven't yet thought to make digital straps with elastic to hold batteries and memory cards (like the film camera straps that provide places for film cans), you can bet they're coming.

# PART 2

# Digital photography alternatives

As well as the digital still camera, there are other devices that you can connect to your computer to capture images. All of these devices might rightly be called *digital cameras*, but they are distinguished from what most people think of as digital cameras because each is aimed at a specific application. However, their applications widely overlap because all produce video and still images that your computer can capture, manipulate, and post on the web. Depending on your photo needs, you could substitute one of these other cameras for a digital still camera.

More than a matter of nuance, the differences have a major effect on image quality, application and what you pay. Here's a comparison of the three major types of camera that you can connect to your computer.

## Webcams

Webcams specialise in images that whisk through the Web. That is, images that can be transmitted quickly through slow modem connections. These images are by necessity compact but low quality. Although you can print them out, even put them in newsletters, on paper their lack of resolution soon becomes obvious when blown up beyond wallet size – every line is more jagged than a lightning stroke. That said, still images captured with a webcam may be sufficient for illustrating an on-line auction item or putting a face on your website.

Most webcams also lack the convenience of internal storage. Their images are meant for the moment, to be sent along as video or captured by computer software. A webcam usually plugs into a USB port and streams video into your computer in digital form. Disconnected, it can do nothing. A webcam is not meant for field photography.

Meant for only the small screen where 320 x 240 pixel resolution is the norm, the webcam usually has an inexpensive fixed-focus, wide-angle, low-quality lens. Although software allows you to capture still images, webcams are designed to capture video at smooth 25 frames per second rates, but they often achieve only 5 or 10. On the positive side, webcams are usually inexpensive – £20 to £80.

Webcams produce low-resolution, slow-frame video designed for sending a view of you over the Internet.

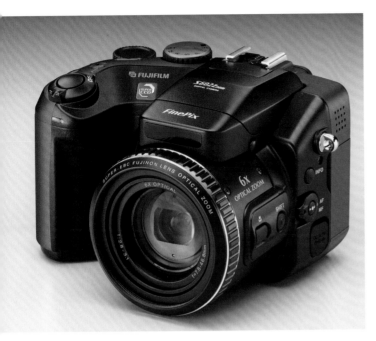

Digital still cameras produce the highest quality images and are meant for taking out into the field.

## Digital still cameras

Digital still cameras take still images and store them internally. Most, however, have additional capabilities that let them work as both webcam and digital camcorder. Although designed for taking in the field, many digital still cameras will connect to your computer with a video cable to supply it with either an analog or digital video signal. These may require you to add a special analog video capture or FireWire port to your computer. The video signal is not at the full resolution the camera uses for still image capture. Rather, it is standard video resolution, about the same quality level as a VGA computer image (640 x 480 pixels).

Once you make the video connection with a digital still camera, you can send its images across the web as you would with a webcam. Or, with suitable software, capture them digitally to make movies. (You can also connect the analog video output of a digital still camera to a video cassette recorder (VCR) and make home movies that way.)

Digital camcorders produce top-quality video but often can take snapshots, or stream images to the Internet.

## Digital camcorders

Digital camcorders aim their outputs at tape and television, with resolution and frame rate keyed for standard television signals. Many of the latest digital camcorders also have still-image modes, which can make snapshots that you can download to your computer and use as if they came from a digital still camera. The still images from a digital camcorder are good enough for most web-based applications and may even produce acceptable on-paper images – if you keep them small. Link the output of the digital camcorder to your computer (using an analog or digital video input, if your computer has one) and you can even use it as a webcam.

As still cameras, digital camcorders suffer from the limited resolution. Video, after all, is not a high resolution medium and requires only about 300,000 pixels, less than the low-end of decent digital still cameras. Their lenses are made to match – not very sharp compared to the optics of still cameras but often with extended zoom ranges (some go 30x and beyond) that a still camera aficionado might kill for.

Most digital camcorders fall into the price range of prosumer digital still cameras. The best, however, rival the cost of the best professional digital cameras.

PART 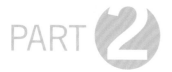 **Scanners**

Conventional photography – loading film and sending it out for developing – is still the better option in a handful of situations. Venture away from civilisation – safari up the Congo or cruise down to Antarctica – and you'll be far from the nearest power outlet that can recharge your camera's batteries. When you dive to explore the corals of the Cayman Islands you may be reluctant to dunk £2,000's worth of camera into a few fathoms of corrosive sea. End result: a box of photos and no way to funnel them into your computer.

Digitise your family history using a flatbed scanner by converting your old shoe box or case full of old photos.

You face the same problem if you're like most photographers and have box upon box of slides and negatives from years ago stacked high in a cupboard or attic. Someday you intend to organise them, and the idea of filing them along with your digital camera photos, even editing them on your computer along with your digital shots, is quite tempting.

A scanner bridges the world of conventional film photography with today's age of digital imaging. With a scanner, your regular photographs become digital with all the flexibility the electronic medium allows. Anything you can do with a digital photo, you can do with the scanned image. You can even combine pieces of digital images with scanned images. Scanning also helps preserve your photos (remember, digital images don't fade).

Temper your desires with two facts. One: Scanning is time-consuming. Plan on spending several minutes per raw scan, dozens if you aim for perfection. You can spend an evening on one roll of film. Two: unless you plan a lot of scans, the equipment costs make the overall process quite expensive. With a film scanner, the breakeven point occurs in the hundreds or thousands of scans. If you don't plan to make at least that many, you'll do better letting a professional scan your prints, negatives or transparencies.

Then again, if all you want to do is consolidate your scrapbooks or move snapshots from photo album to the Web, you don't need a special, expensive photo scanner. Almost any modern flatbed scanner will grab images from your snapshots with all the colour and sharpness you need.

## Flatbed scanners
Flatbed scanners are general-purpose machines, able to yield images from documents, photo prints, even three-dimensional objects. They are inexpensive and yield moderate resolution (about 1,200 dots per inch) and good colour capability, good enough for scanning photo prints.

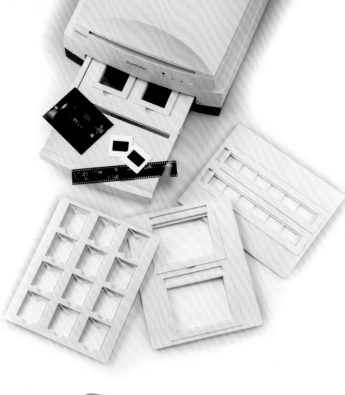

## Transparency adapters
Transparency adapters extend the capabilities of the flatbed scanner to include photo negatives and slides. Although they can yield acceptable contact sheets, resolution is not usually sufficient for high-quality digital prints.

## Film scanners
Film scanners yield high-resolution (1,700dpi to 4,000dpi) scans of negatives and slides. Although more expensive, the results compare favourably to the best digital cameras. Professionals use high-end digital scanners in their everyday work.

### WHAT YOU NEED TO KNOW ABOUT SCANNING

**Resolution** describes how sharp the scans will be. For prints, 600dpi is sufficient for most purposes, but you'll need more for slides and negatives. For 35mm films, you'll want at least 2,400dpi for professional-quality scans. Colour-depth (also termed bit-depth or dynamic range) describes the number of bits used to encode the colours of each pixel of each scan. Although 24-bit colour is enough for monitors, you'll want 32-bit or 48-bit colour in a scanner to give you enough range for enhancing your images.

**Scan area** describes how large an original the scanner can make into a digital image. Flatbed scanners can handle A4 and larger images, although many transparency adapters have smaller limits. Most film scanners aim for 35mm (and APS) films. Film scanners for medium format (6cm x 6cm) and larger are substantially more expensive (three times or more in price than 35mm models).

**Interface** describes the connection between the scanner and computer. Parallel is slow; SCSI often is fastest (and most confusing). Today's choice is USB or FireWire, which is the best compromise in scanning speed and convenience. You'll need a USB or FireWire port on your computer, too.

**Auto-feeders** let you load a strip of negatives into a film scanner and have the scanner image them one-by-one. The auto-feeder saves both your time as well as wear-and-tear on your negatives.

**Software** can make a big difference in scanning film negative and slides. Be sure the software that accompanies a scanner compensates for different film types, each of which has its own density and colour-compensation needs. If the scanning software can't match the film, you'll spend hours trying to get the colour right on each shot.

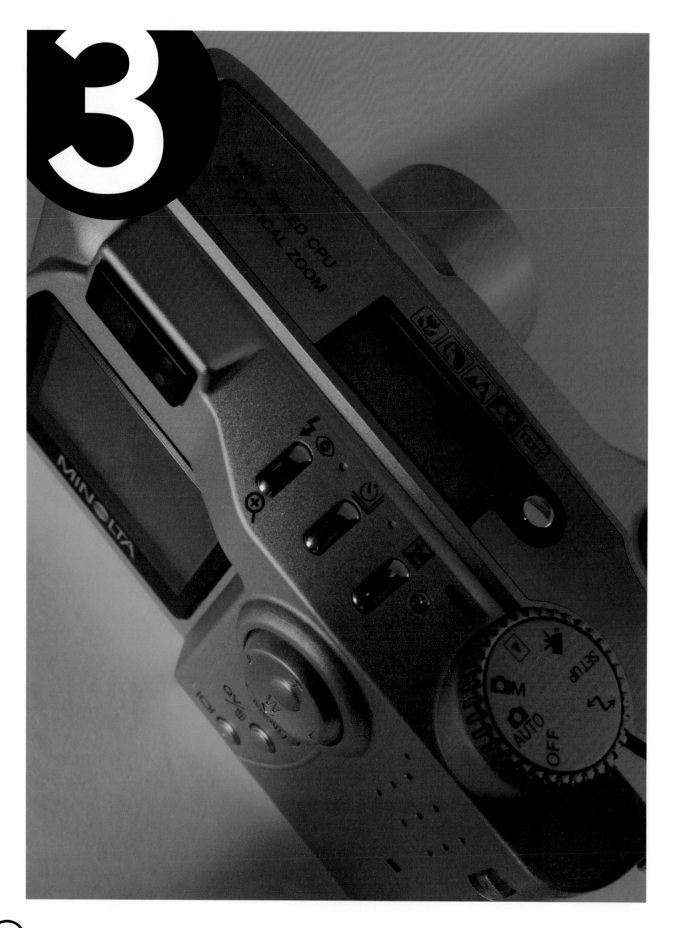

PART

DIGITAL PHOTOGRAPHY MANUAL

# Using a Digital Camera

PART

# Your new camera

The typical digital camera box is covered with claw marks – evidence of new owners rushing to tear open the package and start taking pictures. Who can blame them? You have a new toy and you want to try it out. That's why many manufacturers pack their products with alkaline batteries – so you don't have to wait overnight for rechargeables to be ready for your first exposure. Slide in the new batteries, and start taking pictures.

## Auto everything

Pick up the camera and look through the viewfinder. Find the loved one who is having doubts now that you've shifted your entire attention to your new camera. Push the shutter release and take your first picture. Digital photography is that easy.

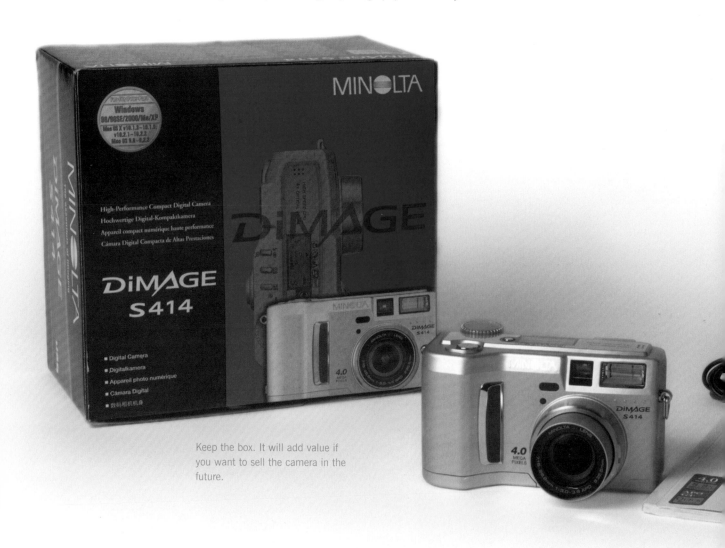

Keep the box. It will add value if you want to sell the camera in the future.

## Focus

Now step back and check out what's going on behind the scenes. If you've got a mainstream or better camera, check out the autofocus system. Observe how long it takes to lock on an image and how your camera lets you know you're there. Check the focus lock.

## Zoom

Try out the zoom if your camera has one. Get to know which button you press (or which direction you twist the lens) to zoom in and out. Get familiar with it – you'll want it to be second nature.

## The menu

Take a look at everything your camera has to offer. Most digital cameras will put a full menu on their LCD control panels or view screens. Push the menu button and familiarise yourself with how to step through the entries and how to make changes.

## Manual modes

Look for the button that lets you shift to manual control. You may find separate buttons or switches to give you manual control of focusing and exposure. Operate the manual controls and observe their effect on the camera's view screen.

## Review

Switch the camera to playback mode. With most cameras, your last shot will appear on the screen. Using pushbuttons – typically the zoom control or menu toggle – you can step through all the shots you've taken. You can review in other ways, too. Your camera may give you direct access to multiple display modes or you may need to visit the menu.

While you're there, check out the equivalent of the brakes on your car – the delete button. Check out how to eliminate images you don't want to keep.

## Battery's dead

The final lesson is how quickly those alkaline cells peter out. You may get as few as a dozen (or a few dozen) shots from a set of batteries. You probably didn't know that digital photography would be so expensive. It's not. Your rechargeables should yield you a hundred or even hundreds of exposures per charge. Breathe a sigh of relief.

## Read the manual

We have to add this footnote about reading the manual because when something goes wrong, that's the first thing the guy answering the camera maker's support line will tell you. So, be sure to read it. Sit down in an easy chair and go through the manual page-by-page and identify each feature and button on your camera as it is mentioned.

What a waste of time! No one does that. No one tries all those obscure camera features until they need it to take a picture – then they fumble around and guess for half an hour before pulling out the manual. You probably didn't even read these pages until well after you'd explored your camera.

You might as well have fun and take pictures and learn as you go along. Besides, even if you tell the support technician you've read the manual, he won't believe you.

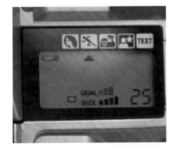 

# PART  Operating modes

The art of photography begins before you compose a shot. By the time you put your finger on the shutter release you already have an idea of what your photograph will look like. Not only have you selected a scene but you've also adjusted settings for the proper exposure, including focus, shutter speed and aperture – or opted to let the camera take care of the details. A given digital camera can either aid or hinder your shooting, making it easy to capture exactly the shot you want or making it impossible.

As explained in Part 2, most digital cameras give you three alternatives in shooting. You should consider how a camera handles each before you opt to buy it.

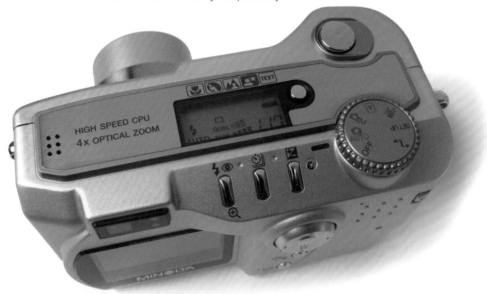

## Automatic mode

Automatic mode is essentially point-and-shoot photography. You give up total control to the camera. It sets aperture and shutter speed. It may decide whether to use the flash or even whether to let you take a photo. If you don't want to deal with the intricacies of photography and if getting a representation of a scene is more important than capturing the perfect image, then automatic mode will be the choice for you.

When comparing the automatic modes of different cameras, consider the speed and effectiveness of the choices the camera makes. Speed is important because it determines whether you can capture what you see when you see it. If the camera takes forever to focus and adjust itself, you may miss an important shot. And if after all the rigmarole of finding its settings the camera misses the mark, you're not going to be happy with the results – or the camera.

## Manual mode

Manual mode gives you total control. You set aperture, shutter speed and other functions as applicable. The mistakes that get made will be yours. But you'll want a camera that doesn't get in the way of your making those mistakes.

Manual means different things to different camera makers. Some may elect to give you control of everything, while others may only give the illusion of manual control, allowing you to tinker with settings but leaving the final say with the camera.

Before you buy a specific digital camera, consider the range of adjustments it affords you. Consider the ease in making the adjustments. And consider whether the adjustments actually have any effect on the final image. Some products have the irritating tendency to override (intentionally or unintentionally) your choices.

## Programmable mode

Programmable mode is also interpreted in different ways by camera makers. For some, programmable mode is an extension of automatic exposure – where the program takes control of all settings. To others, programmability gives you control of how the camera makes its automatic adjustments. You choose how you want the camera to act, whether it thinks you want to make a still life or capture a race car streaking across the track.

Obviously the first step in judging a camera's programmable mode is determining what the manufacturer means by its program. From there you can determine whether that kind of program will help you make the images you want.

Don't just pick up the camera in the store and aim it at the salesperson. Shoot as much as the salesperson's patience will allow (then shoot a little bit more). After all, you won't be wasting film, nor will you have to wait for results. Shoot wide and close-up. Shoot through the front window. Shoot into the dark black stock room. Wait and listen to what the camera does, then look at the results.

# PART  Focusing and exposure

Inexpensive cameras are the easiest to use. You just push a button and take a picture. What could be simpler? The bigger question is, why should it be more complex?

Advanced digital cameras give you a choice of shooting modes. The simple button press becomes the basic shooting mode, single shot. But many cameras offer several others. Consider the mode available to you and how they operate when you choose a camera. Some are based on focusing, others on speed versus resolution. Still others on exposure. Pick the right mode, and you're bound to get a perfect photograph. Choose badly, and you may miss the shot of the century.

The school playing field is a great place to help you practice focusing.

You need a good continuous focusing system to keep up with a bike hurtling through the air.

## Focusing modes

Autofocus is a wonderful thing, but when it goes bad you get auto-out-of-focus. The problem is when your subject is moving or you are panning your camera across the background. Every movement of camera or subject requires a re-computation of focus to be sure everything is sharp.

Fixed focus mode lets you focus on one object then lock that focus distance for subsequent exposures. You'll want to choose this mode if you're following a subject moving across your field of view. This mode allows you to shoot faster because the camera need not focus between shots.

Follow-focus mode (or continuous focus) tells your camera to continually refocus as the scene changes before it. The focus for each individual exposure may be different. If your subject is moving towards you, this is the best mode to use.

Manual focus mode puts everything in your hands. You select the initial focus, and you reset it whenever you feel that you need to, between exposures or not. Choose manual focus when your subject confuses your camera or you want to take control for a particular effect.

A wide aperture was selected to ensure shallow depth of field and focus just on the cat's paws.

## Exposure modes

The automatic exposure systems in new cameras are fast and accurate – but not always perfect. Consequently, camera makers have endowed some high-end products with modes that can accommodate (or compensate for) any lighting condition.

Programmed exposure mode checks the lighting of every scene, and sets the camera's aperture and shutter speed to match. Camera makers select programs to suit subject matter and offer a choice of programs for action photos, landscapes, portraits and so on. Program mode is the best choice for general photography.

Bracketing the exposure will ensure one correctly exposed picture.

A fast shutter speed was selected to freeze the car and its dust trail.

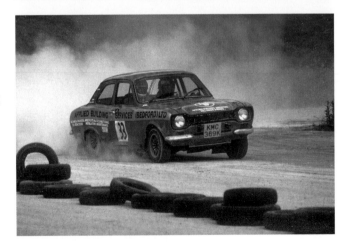

Aperture priority mode lets you set the lens aperture and adjust the shutter speed to match. This mode is most effective when you want to control the depth of field or depth of focus, leaving the iris wide for portraits or keeping it small when you want to squeeze the most near and distant detail into a landscape.

Shutter priority mode lets you set the shutter speed, and the camera sets the aperture to match. This is the best choice for action photos and for particular photographic effects – fast exposures to stop action or slow exposures to blur moving subjects.

Auto-bracket mode turns every shot into three: one a stop or two underexposed (according to the autoexposure system), one at the right exposure and one a stop or two overexposed. Odds are that one of the three will be at the perfect exposure setting even if the automatic reading is a bit off. Professionals often bracket their exposures, and this mode takes care of the details for them.

# PART ③ Capture modes

Image capture is a digital camera's response to your shots, the actual act of converting patterns of light into bytes stored in memory. Although all digital cameras must carry out the same basic functions, they all have their own individual variations on the theme. The way they deal with these basic functions can determine how, and how well, you can make your photographs.

The different ways that a given camera deals with the minutiae of exposure and storage are its capture modes. In general, digital cameras have two or three of the capture modes. Differences abound in how each camera maker implements these modes, differences you should consider before you buy a specific camera.

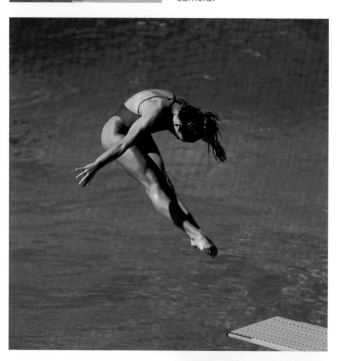

## Single shot mode

Single shot mode is the normal shooting style for a still camera – you look at a subject, take a picture and start hunting for the next image. Each image is a distinct situation with little or no relation to the next. You might take two pictures of the same subject or put the camera away and wait till next week (or whenever) to snap the shutter again.

Be sure to judge the exposure delay, the period between when you press the shutter release button and the camera actually makes the exposure. Try this indoors so the flash goes off and unambiguously tells when the exposure actually happens. You'll find delays an insignificant few milliseconds (a film camera may delay about 40 milliseconds) to an agonising second or so. Although the latter is no problem if you have the camera on a tripod and are taking posed 'studio' pictures, it makes capturing candid snapshots frustrating.

With a moving or active subject, getting the perfect shot can be a matter of luck. You have to hope you click at just the right moment. You can increase your odds of getting the best shot by taking more exposures as quickly as possible. Many digital cameras help out with sequence exposure modes.

In single-shot mode it's up to you to capture the decisive moment. You must learn to anticipate the perfect shot and snap the shutter at the right moment

## Continuous mode

Continuous mode is like having a point-and-shoot camera with a built-in winder. You hold the shutter release down, and the camera keeps taking pictures as quickly as it can. In this mode, you can take a series of action shots – just don't expect stroboscopic studies in Muybridge-like sequences. Digital cameras are not that quick. Not only must you endure the delay in preparing to take a picture like that of single mode, you also have to wait while the camera processes each image and recovers to get ready for the next. Although your images don't have to actually develop, the camera must move every bit of data from the image sensor into its memory, compressing it along the way, while recharging the flash. With today's megapixel digital cameras, you can expect to wait three to five seconds between the exposure of each frame. In practical terms, that means even in continuous mode you may get just one shot at Bigfoot unless you invite him (or her) to tea.

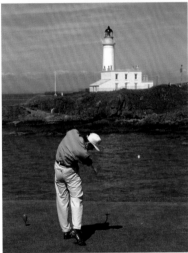

In continuous mode, you only need to hold down the shutter release. The camera captures an entire sequence of action from which you can pick the shot that shows the right moment.

## High-speed continuous mode

High-speed continuous mode is a more rapid-fire means of capturing a changing subject, like a power winder on a professional still camera that can rip through an entire roll of film in three seconds. With a digital camera, this high-speed mode exchanges image sharpness (resolution) for quicker rates, in the region of two or three per second. By limiting image resolution to VGA level, the camera cuts the amount of data it must move to memory to a quarter or less, thereby trimming transfer and compression time.

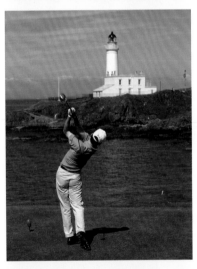

## Best Shot

Nikon adds a unique Best Shot Selector to its continuous capture mode that automatically selects the best shot (in terms of exposure – it has no aesthetic sense) from a sequence of photos, saving storage space and your time in editing images.

When comparing the continuous modes of digital cameras, consider both frame rate and image quality. In addition, check the flash recovery time, the recharge period for the flash unit. It should be about the same (or less) as the continuous mode shooting speed so that you can take high-quality flash pictures at the maximum rate of the camera.

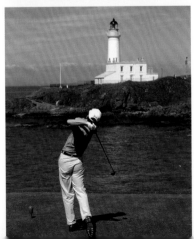

USING A DIGITAL CAMERA

# Self-timer

The ultimate in automation, the self-timer takes away your one remaining creative role in operating a point-and-shoot camera – the shooting part. The self-timer clicks the shutter for you, at a time you hope is of your choosing.

The self-timer functions as a shutter delay. Press the shutter release button, and the camera waits seven to ten seconds before operating the exposure and shutter mechanism. The delay has two functions. It gives you time to get around the camera and into the exposure. And it gives your camera time to settle down after you touch it so it can give you a rock-solid image.

A self-timer lets you join the family for a group portrait.

Digital cameras provide a visual indication of the self-timer's countdown.

## Join the group
The pre-eminent use for the self-timer is putting you in your shots. Put the camera on a tripod, start the timer, run round and join the group in front, and click! The camera takes the picture.

## Watch the blinking lights
Better cameras add an audible or visual indicator to their self-timers to give you a warning before the shutter opens. Typically the camera may beep or flash a red LED at one second intervals, then go continuous for the final second before exposure.

## Steady now
Many pros rely on the self-timer when they need the ultimate in camera steadiness. Even the most careful press of the shutter-release jars your camera slightly. Use the self-timer, and there's no hand to shake anything. All you need is a subject that's patient enough to wait for the timer. Say a slow glacier.

## Remote release
The alternative to the self-timer is the remote-release. For steadying the camera, professionals use short (half a metre) remote release cables. You can get a 5m (or more) pneumatic release for a few pounds. Screw one end into your shutter release, join the group, and squeeze the bulb for an exposure. Some digital cameras have electronic remote releases, some of which can even take time-lapse photos.

# PART 3 Image transfer

You'll soon find, in the excitement of using your digital camera, that its memory has become filled with more photos than you know what to do with.

Actually, what to do with them is easy – get them out of your camera to make room for more. Although every camera maker has their own ideas about the best way to move images, most give you the same choices. You can either plug your camera into your computer (or directly into a printer), use its memory card as an intermediary, or (in a few cases) use an optical link.

The disadvantage of cable and optical links is that they tie up your camera. When you're in the middle of an exciting bullfight, you won't want to put your camera down for ten minutes to pull the old images out. Use multiple cards to move your images, and you can reload in seconds and keep shooting. You can unload your images later or have someone else do it.

## Plug-in

Every digital camera has a hard-wire connection. You get a wire, and jack on the camera to plug into, and (you hope) you have a port on your computer for the other end. Current cameras prefer the USB connection (but you'll need Windows 98 or newer to use USB).

*Install the manufacturer's software on your computer. Do it first so your computer recognises the camera when you plug in.*

*Plug into the camera. Just find the jack and slide the connector in. You might want to save battery power by plugging in your AC adapter at the same time.*

*Put your camera in Play mode or otherwise set it up for image transfer. Your camera must be switched on to transfer files.*

*Plug the other end of the cable into your computer. A USB connection should be immediately recognised.*

*Run your camera's software to download the images. Alternately, your camera will appear as a device like a disk drive in Windows. Just drag your images from camera to a folder on your computer.*

## Slide-in

Cameras with removable media let you slide your images out and blank media in. You can then slide them into an adapter and into your computer to download them. This is often the fastest and most direct means of transfer. And it doesn't tie up your camera.

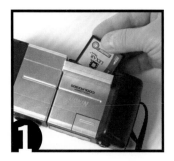

*Slide the memory card or stick out of your camera. If you have a spare, slide it in to replace the full card.*

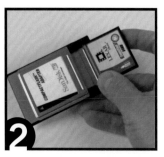

*Slide the card or stick into a PCMCIA adapter. This lets you put the memory directly into the PC Card or CardBus slot of your notebook computer.*

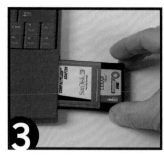

*Slide the adapter into your computer. Any PCMCIA slot will do. Your computer should immediately recognise the card (Windows has most memory card drivers built-in).*

*The card looks like a disk drive, so you can drag-and-drop your images into another folder. Once you move them, erase them from the card or use Windows' MOVE option instead of the copy function.*

## Plug-and-slide

Desktop computers often lack the PCMCIA slots needed to slide-in camera media. A card reader will give you the necessary interface. A card reader is nothing more than a card adapter tethered to a cable which, typically, plugs into a USB port.

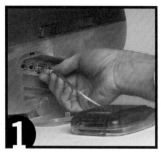

*Plug the card reader into a suitable port in your computer. Install the driver (if necessary) for your computer to recognise the reader.*

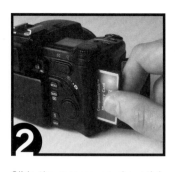

*Slide the memory card or stick out of your camera. If you have a spare, slide it in to replace the full card.*

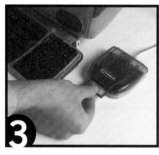

*Slide the card or stick into the card reader.*

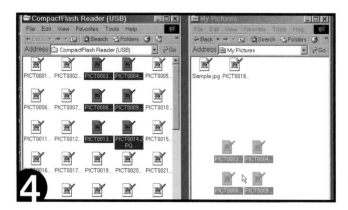

*Use the reader's software to move the files onto your disk. If the card reader appears as a disk drive to your computer, simply drag-and-drop your images onto your disk.*

*Erase the images from the card to gain free space or use the Windows MOVE command instead of Copy to delete images after you've copied them to hard disk.*

# Optical links

A few digital cameras have IrDA ports, ports that connect to your computer by infrared light instead of wires. To use an optical connection, you'll need a computer with an IrDA port or an IrDA adapter (which, frankly, are becoming hard to find). Many, but hardly all, notebook computers have IrDA ports.

*Switch your camera on and use the menu to be sure its IrDA port is turned on.*

*If you have Windows 95 or 98, run the necessary support software to set-up the connection.*

*Bring you camera within range of your computer. The dark red Ir 'eyes' should face one another.*

*Your computer should make a sound to indicate when a connection is achieved. An icon should appear in your tray.*

*Use the software provided by your camera manufacturer or drag-and-drop the images from the appropriate folder.*

# PART  Becoming a Digital Photographer

PART **4** # Getting started

Your new digital camera is quite likely not your first camera. Film has been around so long that everyone has some experience with a conventional camera – loading film, peering through a viewfinder and waiting some time to discover you missed the shot of a lifetime.

A digital camera isn't all that different from an old film camera. Even with the addition of more technology than most mere humans can understand, picture-taking remains much the same process. You point the camera at your subject, click the shutter release and hope for the best. But all of that technology has an effect. Digital is different, sometimes subtly so, sometimes rudely so. Mastering digital photography calls for recognising, understanding and taking advantage of these differences.

## How digital is different

**The busy finger** When every shot costs 50p or more, your finger can get stiff on the shutter release. With digital, there's no film or developing cost, so you might as well snap away. If you have the least doubt, don't hesitate. Take a picture.

It would have been good to have the ball in shot but the shutter delay caused the photographer to miss the moment

**Anticipate** Because of the longer shutter delay, you'll have to press the button well before you think you've got the right shot. You have to anticipate by dozens of milliseconds more – or miss the shot. You already anticipate shots with a film camera – you just have to learn to click sooner.

**Beware the battery** Digital cameras depend on their batteries. Unlike film, where you know how many exposures remain on a roll, digital camera batteries are apt to expire without warning, usually right before a critical shot. You'll never want to go far without a spare set. And another one, just in case you forgot to charge.

**Fewer attachments** Don't bother with a clutch of special effects filters. You don't need much in your camera bag with a digital camera. Nearly all of the effects that require attachments and filters with film cameras are accomplished more easily (if not better) during editing on your computer.

Soft focus used to require a bit of Vasoline on an old filter, a nylon stocking in front of the lens, or special soft-focus lenses and attachments. Your editing software can blur anything – with exquisite control. You can get more precise and controllable selective focus using masks.

Colour filters helped film cope with odd lighting, but the white balance of digital cameras takes care of that automatically. If you want to change the colour of your subject or the mood, you can do it easily and repeatedly with computer software.

Soft focus can be created after the photograph has been taken using image editing software.

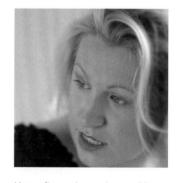

Use software to create mood by adding a single colour tone.

# Finding your shot

Film cameras give you exactly one view, through the viewfinder, leaving you to guess what actually will appear on paper. All but the least expensive digital cameras give you three views – through the view finder, on an LCD view panel or through a remote video connection. The choice can change the way you photograph.

The viewfinder is for fast shot – action. It's always ready and your eye accommodates to it in an instant.

The view panel lets you compose. It's like the ground-glass screen of a view camera but the image is not upside down. You fiddle with a digital camera on a tripod until you get your shot exactly right.

But the view panel is not for everything. It can get between you and your subject if you hold it at reading range. For portrait work, you may want a digital camera with a rotating view screen.

A prosumer digital camera's video output gives you a big view, so you can preview every detail of a studio photograph without contorting yourself to see a ground-glass screen.

The LCD viwfinder helps you align a photo.

# PART  Ten-minute art school

Most of the photos that most photographers take are the 'smile and say cheese' variety. There's no reason to avoid such photos. They are your memories captured in digits. But if your sights are set higher and you want to take memorable photographs rather than just photographing memorable situations, you need to add some skill and variety to your efforts. To acquire such skills you can sign on for a college course in photography or you can home-study the ten-minute art school which follows. Before you start, fix one thing in your mind – move around. The best photographers know that point-of-view makes or breaks a photograph. You need a different angle, direction, or whatever, for impact and fun.

## PHOTOGRAPHY AS AUTEUR

A photo is a story. As with writing a story, know what you're going to say before you start, otherwise you're apt to ramble, wasting time on shots that don't work out and more time on editing the chaff away. Every story benefits from a bit of mystery, something to net the interest and imagination. In photography you can add mystery by what you don't show or by leaving part of your photo unexplained. Put a question in the mind of your audience: What causes your subject to react so? What lies beyond the edge of the frame? Where does that stairway lead?

## Four steps to better photographs

Here are four steps that summarise a term's worth of college photography training:

**Snap first** *When you see a photo, take it immediately, before worrying about any of the details like focusing, a better position, better lighting, or better timing. Then you at least have something – and with a digital camera, you won't be wasting film.*

**Find a viewpoint** *Once you have a shot to cover the situation, move around. Try to find the optimal viewing angle to improve on your shot. Get closer or further away. Move left or right. Stop that tree from sprouting from the head. Make the subject loom up from the surroundings. Take a shot from each and every position. You can edit away the ones that don't work later.*

**Make it perfect** *Now worry about the details like timing, lighting and focusing. You've got a picture, now get the best picture. Try several variations. When in doubt, take the photo and edit it away afterwards.*

**Wait a while** *When photographing outdoors, you watch how the scenery changes as the sun moves across the sky and hides behind clouds. Once you have your greatest-of-all shots set-up, it's time to let Nature improve it. Watch the lighting. As it changes, try another shot. Some professionals wait all day for the perfect low-level evening light.*

**Frame your shot** A frame focuses attention inside. Your photos can include their own frame inside. Take a shot through a window, out of a cave, or use a doorway or ruins to frame your subject. You'll add drama and draw attention to the subject.

**Get closer** Even if you forget everything else, the most important rule is to get closer to your subject. This usually takes photographers up at least a notch in skill and results and it will improve the quality and impact of the photos you take. Your eye views the entire world, but your attention focuses on a small area. It's only natural – only the centre of your retina is sensitive to detail. Getting closer means your photos centre more on the subject with less of the surroundings to distract.

Inexpensive digital (and film) cameras use wider lenses that give a wider view. If you want to tighten your focus, you have to get nearer to your subject. If you're in the field, you'll have to hike over to your subject. Certainly you can overdo it – lenses focus only so close – but taking a few steps closer from where you initially conceived the shot often improves the photograph.

Sometimes you can't get closer. For example, the authorities may fence you away (and good reason when lions, tigers and bears are on the other side). Or your subject may be across a stream or chasm. A longer lens – one with a greater focal length, often a telephoto lens – will take you closer even when your feet cannot.

When you can't change the lens on your camera, the only alternative is to make the best of what you have. If you have a zoom, use it. Take yourself closer to your subject through optics. (But every rule is proved through exception, so take a photo when not zoomed in as well!)

**Cropping** What you can't do when taking the photo, you can sometimes accomplish in editing. Severe cropping yields the same effect as taking steps closer to your subject. But after-the-event editing bears a penalty: you lose image quality with every pixel you sever from your image (see page 122).

**Find a new view** The typical photo is the straight-on view. You confront your subject as you would a burglar going through your desk drawer. The memorable photo looks at the world differently, seeing what you may have missed in your confrontation. Take a moment and find a new way to see your subject.

If the subject looks down or away from the camera you won't be troubled by red eye.

Move close with a wide angle for dramatic results.

Use a doorway or arch to frame a shot.

Including foreground leaves as a frame helps add depth and perspective to photos.

**Make it giant** Exaggerate perspective and make small objects loom larger by getting close with a wide-angle zoom and, if you have one, an auxiliary wide-angle lens. Get as close as you can while keeping most of the subject in the frame.

**Front and back** In travel photos, combine the location and your subject in one shot: put the spouse and the cathedral in the same shot. Pan your camera so the subject is on one side, the landmark on the other. Sometimes you may have to crouch or stand on a wall to get your angle. The results justify the effort – there's no other way to say you've really been there.

**Red-eye dies** Certainly you can fix the demon-like red-eye that arises in flash photography, but you can avoid it with a new angle, as well. Simply arrange your photo without your subject staring into the camera.

**Web-page look-up** You see them on almost every web page – the face looking up with little feet. It's easy to do. Use a wide-angle setting to emphasize the face and shrink the feet. Use a ladder or stairway to look down on your subject.

**Near and far** Including a nearby object in a landscape helps draw the viewer in and adds distance perspective. Often, however, it's a choice of which to have in focus, nearby or far away, depending on what you want to emphasise. You can put both in focus digitally – make two exposures (one focused close, one far away) then paste the sharp nearby image on the sharp distant scene.

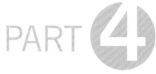 PART

# Action and sports

Sports photography is a true art, practised by a field full of professionals who have honed their skills with years of experience and special passes to get close to the action. Although you'll have to work hard to capture a front-page shot every day like they do, with a bit of insight and practice you can produce some good results.

The emphasis is on action and conveying that action in your photographs. Your subject doesn't stand still, and neither must you. Here are a few tips:

**Be quick** Because action and sports photos are about motion, shutter speed is the most important setting. You want to set the shutter speed as high as possible – typically at 1/500th to 1/1000th second. If your camera has a program mode, selecting the 'action' setting will make a high shutter speed setting a priority.

**Open up** High shutter speeds mean wide apertures, but you'll want to keep your iris small to get better depth of field to cope with moving subjects. If your camera lets you set a higher effective film speed (the ISO or ASA equivalent) select the highest setting, but be aware you will introduce noise!

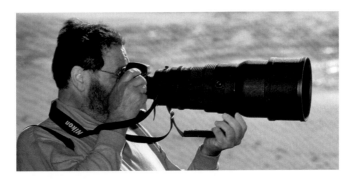

**Go long** Professionals use long lenses with wide apertures – which means very expensive lenses that let them get tight shots from safely off the playing field. The wide aperture helps grab light for high shutter speeds and under lights. You probably can't afford one of their cannon-like lenses, but use your zoom at its longest.

**Get close** The closer you get to the action, the more you and your camera will see. Move in as close as safety – and the officials – will allow.

**Follow the action** Keep your eye on the ball. The action forms around the ball, and by tracking the ball you automatically follow the action. You'll follow every pass and capture every save and goal.

**Pan your camera** In motor sports (as well as biking and equestrian sports), pan the camera with your subject. As a car, bike, or horse passes in front of you, twist your body to move the camera to follow the action. The background will blur with your speed, but you'll capture your subject in sharp (or at least sharper) focus.

**Pre-focus** With field sports, you know where the action will be – where the discus is released, whether the vaulter clears the bar, where the long-jumper lands. Pre-focus on the spot. Use the focus-hold setting to lock focus where your subject will be. Then, as your subject enters the target zone, click the shutter.

**Celebrate the victory** When the game is over your job's not yet done. Capture the moods of the players both in joy and defeat. Focus on the faces and the paces, whether a fast clip off the field or a slow drag with the eyes focused on the grass.

# PART 4 Capturing the moment

**A photo taken at a critical moment is likely to bring a lifetime of smiles and memories. Every gift brings a moment of surprise when the wrapping is finally torn off. Every face that crosses a finish line tells the story of the entire race. Practical jokes may even bring two moments – the initial shock of the joke and the severe promise of revenge.**

A digital camera is as capable as any camera of capturing a fleeting moment. Although many early models missed shots because of their inexcusably long shutter delays, today's digital cameras are quicker. Moreover, once you familiarise yourself with your digital camera and gain experience using it, you'll be comfortable compensating for each camera's idiosyncrasies.

Although some people believe that getting the shutter to click at the one right moment is a matter of pure luck, even in spontaneous situations capturing the perfect photograph is more a matter of skill and preparation. Following a few basic rules will help you and your digital camera to capture lasting memories.

## The golden rule

Have a camera ready at all times. After all, you can't take a photo without one. With the advent of the low-cost digital camera, there's no reason not to have one ready whenever and wherever a photo opportunity might arise.

You don't need high resolution when you're only out to take snapshots, and you don't need an expensive LCD viewing screen. So when you find a bargain digital camera, say a discontinued model at £25 or less, buy a couple and keep them ready.

## Don't wait to download

How many times have you been stuck without film when a once-in-a-lifetime scene appears before you? You may think that, because a digital camera doesn't depend on film, those frustrations are finally over. Not quite. You can still get stuck not having space to store another image. If you put your digital camera away with its memory cards packed full of images, you'll have to waste vital seconds – even minutes – freeing up space for new shots. The great auk that landed in your birdfeeder may flutter away before you're ready.

Make downloading standard practice. As soon as you're done with a photo session, download your shots and keep your memory cards clean. That way they will always be ready when something comes up.

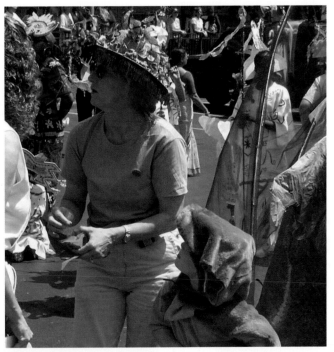

### A WORD OF WARNING

Unlike film photography, you can't depend on your digital camera to sit for months unused on the shelf, especially if you've loaded it with rechargeable batteries. When you call on rechargeables in a pinch, they are apt to ignore you. Because of their tendencies to self-discharge, rechargeable cells may be effectively dead after a few months of storage.

The low-cost, low-resolution cameras you're apt to pack in your car's glove box or keep on the shelf work well on alkaline cells because of their simplified circuitry and lack of LCD view panels. Alkaline cells self-discharge at less than one-tenth the rate of rechargeables, so they will stay ready. Load up with alkalines to always be prepared.

## 90% of all spontaneous events are predictable

No violation of common sense, this rule means that you can be 90% sure that something will happen at a critical photographic moment. You can never be exactly sure what will happen, but it's likely to be something memorable.

For example, a fully lit birthday cake presented to a youngster – you can be sure candles will be blown out. You know the critical moment when the child's lungs have reached peak capacity, so have the digital camera ready with your finger on the shutter release.

Anticipate. Have your camera ready at these critical moments, and snap the shutter when you think something is about to happen. Because of shutter delay, you'll likely capture the perfect moment of surprise.

# PART 4 Close-up photography

If your favourite subjects are small – flowers, insects or gems – you'll need to get close to fill the frame. Close-up photography means taking pictures of subjects nearer your camera than it will normally focus. Typically, that means from a few centimetres to a metre away.

Digital cameras are great for close-ups because you can see (and correct) your results. Try it and you'll soon discover close-up photography is a specialised art. To do it right, you need the right tools for the job.

## Three ways to get close

Even the best cameras and lenses force you at least a metre away from your subject. Lenses simply cannot easily be designed to handle larger focusing ranges. Photographers use three strategies to get closer to their subjects. These include:

***Macro lenses*** *Most camera lenses are optimised to focus at infinity, but many manufacturers offer macro lenses designed to focus on nearby objects (much closer than you can focus with a normal lens) and produce images nearly life-size. Unfortunately, you need a camera that takes interchangeable lenses to make use of a dedicated macro lens.*

***Macro settings*** *Many digital camera zooms (particularly those on prosumer cameras) have a macro setting that alters the formula and function of the lens. Often the zoom control becomes the focus, and you adjust the zoom or image size by moving the camera closer or further from your subject. Some let you go as close as 2cm from the subject.*

***Close-up attachments*** *A supplemental close-up lens attaches to the front of your camera's existing lens and alters its formula so it focuses closer. All controls on your camera work normally (with the exception you can't focus on distant objects with the close-up lens attached). Although purists believe supplemental lenses compromise quality, the results can be surprisingly good.*

## Close-up tips

Capturing the magnificence of a dahlia or orchid in bloom isn't a matter of luck. You need to know the intricacies of the art of close-up photography. Try the following tips, and you'll soon be taking close-ups to rival the pros.

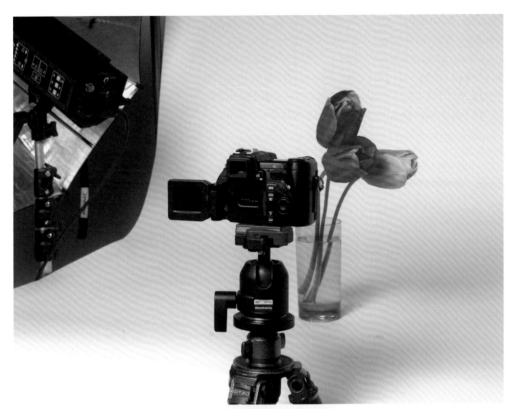

*Lock down* Rather than handholding your camera, use your tripod. Then you can stop all the way down (to f/16 or f/22) and use a long exposure without the worry of camera shake. But you may have to wait for the wind to calm to avoid your subject moving.

*Stop down* The closer you focus, the shallower the depth of field. When you're in close, the depth of field may be only a few millimetres. Stopping the lens down (shift to manual mode or use aperture-preferred automation) as far as you can while keeping a sufficiently slow shutter speed will increase the depth of field.

*Use your flash* Your flash can freeze motion – including your camera shake and flowers waving in the wind. But you'll need to experiment using the flash for fill-in or main light. Try using a reflector or diffuser. Thanks to digital technology, you can instantly check the results. Better still, save all your tests and evaluate them later, on screen or on paper.

*Carry your backdrop* Often when you find the right angle for photographing a flower, the background is all wrong. You can avoid the problem by carrying your own. For dramatic photos, for example, a metre or two of black cloth draped beneath can give flower photos added impact.

*A little spritz* You can make flower photos look more luscious with a little spritz of water spray. Carry a pump-style spray-bottle filled with water, then spray the flower before you focus. You'll get drops of water beading up on petals and leaves, as if you found your flower after a summer shower.

PART  # Landscapes

Natural landscapes are among the easiest images to edit because Nature is forgiving. Matching foliage, grass, or rock outcroppings is easy because there's no need to be precise. Landscape, however, also extends to the urban world and the handiwork of mankind – great gardens, beautiful buildings and even city streets.

Although landscape photography at first appears easy – after all, the landscape just sits there waiting for you to press the button – it can be troublesome. Watch for reflections in windows and water. Although you can match and patch with digital editing, a reflection from a semi-transparent surface can be impossible to fix – you've got to change and match two images. You might as well paint them from scratch. And watch where your shadow falls.

Landscapes can be formal or informal. The formal landscape is art meant to convey an impression, mood or idea. An informal landscape refreshes your memory or gives the memory to someone else. A photo of your house in an estate agent's advertisement is more likely informal.

The difference is mostly the effort you put into it. The informal landscape is cinema verité – raw life with all the warts. The formal landscape is somewhere between nirvana and the Garden of Eden, a place made perfect by the photographer and airbrusher. A formal landscape appears in a frame on the wall or in a book. The informal appears in a magazine ad or your wallet.

You can just snap and take an informal landscape. Your digital camera should take care of the details. A formal landscape takes more work. Take advantage of digital, and fill a memory card with images – move around a lot and bracket your exposure to get every detail of every millimetre of your scene.

Unlike film photography, editing can help make a formal photograph even better, and it can relieve you of many worries and concerns when you snap the shutter. Many of the flaws of a landscape photo are easy to fix digitally.

Just pointing and shooting at whatever scene you see will show. Here trees are in the way. Walking forward to the front of the trees or 100 metres to the left would have given the photographer a better viewpoint.

Look for foreground detail and consider all the elements for a classic landscape.

## What digital can fix

**Intrusions** *like wires, dustbins and errant tourists can be erased with a few minutes of editing. You don't have to zoom in to miss transmission lines or crop drastically to eliminate the occasional trespasser.*

**Contrast problems**, *where you have both bright lights and dark shadows, can be fixed in editing. If a single exposure doesn't have enough contrast range to bring things together, bracket when you photograph and you can paste exposures together to add unlimited contrast range.*

**Colour casts** *are no bother because you can easily compensate with most photo-editing software. Fluorescent lights or overzealous white balancing that eliminates the warmth of a sunset can easily be dialed into the hues you choose.*

**Unhappy** *skies are no problem for anyone with a ready editor and collection of shots. You can add your favourite clouds into any sky, or even make a scene into a sunset.*

# PART  Portraits

The good thing about portraits is that your subject is already decided. Instead of wondering, 'Who?' the question is 'Why?' Why are you taking a portrait? Most pictures of people are casual portraits, capturing a moment so you can re-live memories. Any camera from the cheapest disposable one up will do. As long as your subject is recognisable, the image serves its purpose. Most of the time a smile is mandatory because you want to capture happy memories.

There's no art and little science to the casual portrait – just point the camera in the right general direction. Everyone is sure to ham it up.

The biggest problem with portraits is that your subjects are sentient beings with their own opinions about how things – and themselves in particular – should look. Digital is different because instead of complaining a week later when they see the prints, your subjects can complain immediately when they see themselves on the LCD screen. So you can shoot again before you lose a friend.

In formal portraits, the 'Why?' question leads to 'What are you trying to say?' Is your portrait about the person, the situation, or the cosmos?

A formal portrait requires planning. You must know your message and know how to convey it. It can be as shallow as capturing a pretty face or as wrenching as showing neglect and poverty.

It's just as difficult to take a vacuous photo as a meaningful one, maybe even more difficult. A picture meant to show beauty can be a challenge.

## How digital is different

In digital photography, your camera merely gathers information, raw material. With film photography, your image is complete on the taking, and you have to get all of its elements right: subject, background and effects. Digital gives you the versatility to make a snapshot into art. Where soft-focus to erase all those years requires special lenses with film photography, digital makes it easy to soften wrinkles and erase blemishes. You can work with the background, even paste your subject into a new situation – be it Triton's castle or a lion's den. You can even change the mood. Or paste in part of an expression from one photo into another.

The odd thing about digital is that most of your portraits will be viewed in landscape mode, wide format rather than tall, like your computer screen. Only prints are apt to be shaped like real portraits. Plan your composition according to your intended display.

The basic rule is to take as many pictures as you can, then edit severely. Digital moves the skill from the taking to the making – with the benefit that you can fix your mistakes in editing.

## What digital can't fix

When shooting digital, it's more important to keep in mind what you can't fix rather than what you can. Don't be trapped into thinking you can fix everything with software.

*Lighting is frozen when you take the shot. It cannot easily be changed in graphic editing. You'll want to get it right from the beginning, either to make your subject look good or for the best blend into another image.*

*Although softening focus to erase wrinkles is easy, satisfyingly sharpening the focus of an overly soft shot is impossible (despite the 'sharpen' filters in software). You want to be sure to get everything important sharp to give yourself material to work with later.*

*Movement, like focus, can't be fixed. (Although you can add motion effects, you can't add stillness). Get your subject to stand still and hold the camera steady. Better still, use a tripod and work with your subject.*

*Make-up takes immense effort to repair. You can change the shade of lipstick, but using software to thicken eyelashes and tinting the lids is painstaking work, a job that is best handled before you shoot.*

# PART  Portrait-shooting tips

In concept, a portrait is an easy assignment. All you need to do is capture a person's likeness. But portraiture is an art with few masters. You don't want the subject of every portrait you take to stare into the camera and smile.

Many elements go into making a great portrait – make-up, lighting, the equipment, the photographer and the subject. Most photographers want to control them all – but usually, you as the photographer are in control of only one variable, yourself.

The camera assures your photo will look like your subject. The photographer determines whether the photo will show the real person. You must both know your subject, know what you want to say about the subject, and know what the photo is for. If your subject is the devil incarnate and can wither flowers with a glance, don't ask him to smile and say 'cheese' – unless you want to show his fangs.

## Formal portraits

When you want to make your subject a thing of joy forever, you'll want the full armada of control. Judicious digital retouching can make up for some of the lack of make-up, but can't cure poor lighting.

Most photographers use a moderate telephoto lens for head-and-shoulders portraits. Shorter lenses exaggerate facial features – that means, it makes noses bigger, which most subjects abhor. Longer lenses force you too far from your subject for the give-and-take that usually results in the best images. With a 3x zoom, zoom all the way in. With a 7x or 10x zoom, go about halfway. (That's 90mm to 135mm with a 35mm camera.)

## Environmental portraits

An environmental portrait makes-do with the subject as he or she is, without make-up, backdrop or special lighting – although pros know how to augment natural light to make it look more real.

*Take a couple of shots to cover yourself, then relax and observe. See how subject and environment fit together, then use your camera to bring them closer. Capture an image of your subject's attitude towards the environment.*

*Pull back/go wide. You want to capture the environment and background. Use a moderate wide angle.*

*If you have a tripod, you don't need studio lights because you can use a longer shutter speed without camera movement – but your subject will need to stay still, posed.*

*The most complimentary natural light is a big, diffused source – northern exposure. Get dramatic images working with the window to one side; flatter images with the window to your back (and lighting the subject's face). Watch the shadows as your subject turns his or her head and you move away from the window.*

# Beyond the normal

Most portraits are cliché. It can't be any other way when people take billions every year. If you want a portrait to stand out, one way to start is by being different, even breaking rules.

Take a tip from 19th-century photographers. Backgrounds can be environmental, formal or fake. If your camera lets you, use the widest possible aperture and focus on your subject's eyes. They didn't have a choice, but the effect is still dramatic. This naturally suppresses the background into soft focus.

Give a hard edge by going the opposite way, stop down and flash. You can let the background fade to black or give it its own light.

Above all, aim for variety. Remember, digital means shooting like the film is free. Ask your subject to join you in your rule-breaking. Don't look at the camera. Don't smile. Don't put the subject in the centre of the frame. Cover part of the face with hair, a hand, an aspidistra or even a blank card.

# PART  Still lifes

Today, a still life is apt to be a working photograph, a thing of practicality; for example, product photos. But a still life can also be a work of art, and as that it is more than the basic passive shot of a bowl of fruit or a bouquet. It's heaven for the control freak. Every element is under your direct control.

Most of the art in a still life is in arranging your subject. You can pile oranges and pomegranates into a bowl or put your old modem atop its box. The object is to show your subject.

Digital makes the still life easy because you can see your results as your work. You don't have to wonder whether it will come out. Moreover, you can find happiness in the many-ness of digital. Take enough shots from enough angles, and you can be sure to find one that emphasises features you want to show, or hides the flaws you don't.

For quick product shots, digital cameras make matters easy – it's little more than point-and-shoot. Take a bit of extra time and try each shot with and without fill flash. Depending on the ambient lighting, one or the other may look vastly superior.

If you want to do your still-lifes right, try the tips opposite:

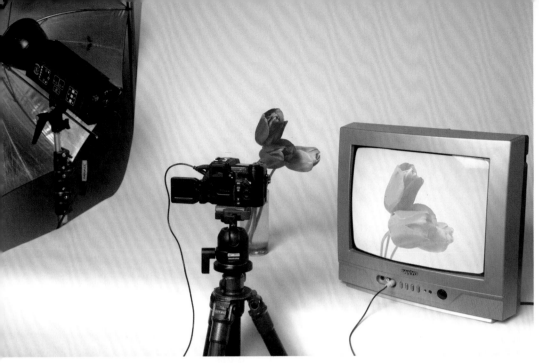

**Tripod** *Shooting with a tripod is especially beneficial for still lifes. You can be sure your shots are sharp because your camera won't shake. You can keep the same framing and focus for many shots, by changing the subject on the stage. You may not even need to recompose. And you can adjust the subject and not lose the overall shot, move the light, or whatever.*

**External monitor** *Seeing what you're doing is what that video output is for. Your digital camera makes a video signal that will put an active image on a television or video monitor. With it, you can view your shots before you make them, adjusting your set-up for the best view on the screen. Once you've got it right, push the shutter.*

**Background** *With a product shot you have one subject. The background is only a distraction. Professionals use seamless paper – a big, wide roll that gives an unlimited smooth background. You can use a sheet or bolt of fabric for a similar effect.*

**Light tent** *Professionals use light tents to tame reflections – a translucent white covering that blocks reflections of lights and props in the studio from appearing on round, shiny objects. You can use white cards or drape a sheet around your subject for a quick shot of that chrome headlight for a for-sale catalogue.*

**Macro mode** *When you have objects that are too small to fill the frame, switch to macro mode if your camera has one. In macro mode, you can focus closer, using your camera zoom to focus. If all else fails, focus as close as your camera permits, then move the camera to get proper focus on the largest image size possible.*

# PART  Black-and-white photography

A black-and-white image is a record of the brightness of your subject. That simple definition belies the power of black-and-white photography. It excels in capturing shapes, patterns, light and moods. One way it gets its power is by stripping off unnecessary colour and focusing your vision on contrasts. At one time, all photography was black-and-white. Now, colourless photography is reserved for art and making an image stand out from the otherwise all-colour world.

Colour is the native mode of all digital cameras. Making black-and-white digital photos requires some form of image manipulation.

Black-and-white gives an old-time feeling to your digital images.

You can make any colour image black-and-white as easily as using your photo editor to turn the saturation all the way down or simply use the image-mode control to make it eight-bit greyscale. Most of the time, however, you'll end up not with a true black-and-white photo but one with crippled colour.

To make a real black-and-white photo, you must take into account the medium's disregard for all else but brightness. The chief issue in composition becomes separating of tones, making your subject stand out from the background – or not. You must be in control of the relationship between objects in your image, which means discerning and separating tones rather than hues.

In the studio, visualising black-and-white is easy with a digital camera – just plug its video output into a black-and-white monitor (or switch off the colour on your colour monitor if you can). In the real world, you can visualise black-and-white images with a viewing filter.

# How digital is different

**Filtering** When converting to black-and-white, you can't simulate the effect of colour filters with most image-editing software. Digital systems usually use the green signal (of the red, green and blue signals that make up a colour image) to make a monochrome image. In other words, the sensor for monochrome images is sensitive only to green light. Applying a filter only reduces the overall green signal. The relationship between the red, green and blue signals is ignored.

In black-and-white film photography, the film is sensitive to all wavelengths, and you can change the relationship between hues and tones with colour filters. Commonly, photographers use red filters to make dramatic skies, blue filters to simulate old portrait films and green filters to lighten foliage and darken skin tones.

With digital, you have to rely on other means to simulate the effect of colour filters. To darken skies, you may have to mask and adjust brightness and contrast values.

**Tonal range** Digital technology records only 256 levels of grey. Paltry as it seems, this is far greater than the capabilities of photographic film. This gives you a wide range to work with in manipulating images, so with creative image manipulation you should be able to pull more detail from shadows and highlights.

**Black-and-white mode** If you're serious about black-and-white photography, look for a digital camera with a black-and-white mode. This mode works more like film photography, capturing an image in monochrome and yielding higher resolution than capturing in colour then converting. Typically, this mode puts every pixel in action in greyscale mode.

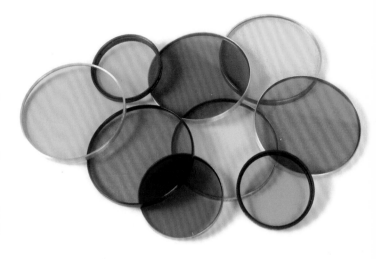

Coloured filters are used in black-and-white film photography.

Colour printers adeptly handle black-and-white images too.

A black and white shot shows colours as levels of grey. It's hard to determine which colour is which.

By playing with the Red, Green and Blue channels individually you can change the tones of individual colours. You do this in Photoshop using the Channel mixer option and here are two examples of how a photo could turn out once 'mixed'.

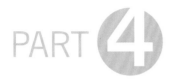

BECOMING A DIGITAL PHOTOGRAPHER

# Infrared photography

You can take photos without light with most digital cameras – at least without visible light. Most models of digital camera let you experiment with infrared photography. Instead of registering visible light of green, red or blue, with infrared photography your camera records images made by invisible light beyond red – that is, with longer wavelengths than ordinary red light. You've probably seen the results of using special films to make infrared photos – typically eerily glowing white trees against stark black skies.

Infrared images often take on strange colour casts – the colour depends on the transmission characteristics of the infrared filter you use and the inherent infrared sensitivity of your camera.

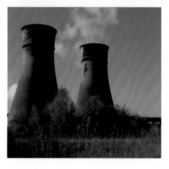

Infrared pictures can be taken with some digital cameras. Blues turn almost black and green foliage becomes ghostly white.

Going infrared requires only screwing a filter onto your camera's lens.

The sensors used by nearly all digital cameras are almost equally sensitive to near-infrared as they are to visible light. For camera makers, that is a problem. The invisible light registers and can cause a blur or shift in the colours registered by the camera. Consequently, most camera makers block infrared from passing through to the light sensor with a hot mirror, a special light filter that stops infrared.

That said, these filter-mirrors differ in effectiveness, and even the best pass a small amount of infrared with which you may be able to make photographs. The trick is to block all visible light from reaching the camera's image sensor and washing out the infrared image.

You can easily block the light by installing a filter on your digital camera's lens that blocks visible light but passes near infrared. Several standard commercially available filters – glass, plastic and gelatin – have this ability. Because of the different infrared sensitivity of digital camera models, some filters work better on particular cameras than others. The only way to be sure is to try a filter and observe the effect.

A quick way to test your digital camera is to install the filter, and point the camera at a source of near-infrared radiation. The remote control of your stereo or television often works for this purpose. Point the LED (light-emitting diode) of the remote control at the filtered lens and watch on the camera's LCD view screen. If you see the LED light when you press a button on the remote control, you can start taking infrared pictures.

Unfortunately, only a tiny bit of infrared gets past the hot mirror of most cameras to the image sensor. As a result, infrared photos require long exposures (1/15th second or longer) at wide apertures. You'll need to set up a tripod to have any hope of a sharp infrared photo.

Digital infrared photos do not look like those made with film cameras. Film-based infrared exposures often have an eerie glow. This glow is a result of overexposure and a shortcoming in the most common black-and-white infrared film. Kodak's infrared film lacks an anti-halation coating, which prevents light reflecting off the back of the film and back to the sensitive part of the film, which blurs the image. Digital cameras do not suffer from halation, so you don't get the glow. Try using a 'blur' or 'soft' filter in your photo editor to emulate the film effect.

You can take infrared photos in the dark if you have an infrared source. These are commercially available or you can make your own with infrared LEDs, available at an electronic parts store.

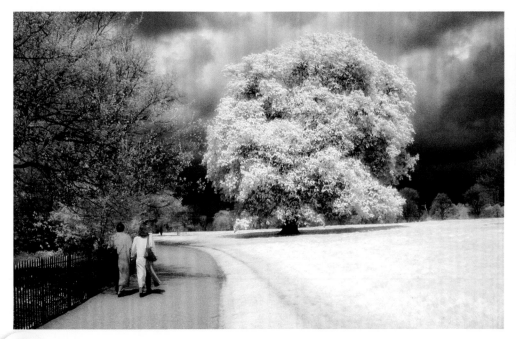

Test your camera's sensitivity by photographing the infrared LED on a television remote control.

To make classic-looking infrared images, convert your images to monochrome. Adding a blurred layer makes a scene glow.

 FILTERS FOR INFRARED

The following Wratten filters pass infrared light and, in order, decreasing amounts of visible light. The type 25 and 29 will create images that are discernibly reddish.

| 25 | red |
|----|-----|
| 29 | deep red |
| 70 | red-opaque |
| 87 | visibly opaque |
| 88A | visibly opaque |
| 89B | visibly opaque |
| 90 | visibly opaque |
| 90C | visibly opaque |
| 90B | visibly opaque |

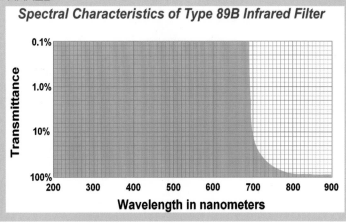

Spectral Characteristics of Type 89B Infrared Filter

Transmittance

Wavelength in nanometers

PART  **Lighting Digital Photos**

PART

# Optimising outdoor lighting

As long as you have enough light, you can take a picture. Lighting, however, distinguishes a good photo from a mediocre one. Lighting can add drama, romance, or a hard edge to your photos.

When you take pictures outdoors, you may think that the lighting is out of your control. After all, you can't command the sun. But more often than not you can change your position in relation to the sun.

## Light to your back

For the last 100 years, Kodak's simple advice has been to keep the sun behind you. That assures your subject will have the sun in his or her face. Although the bright sun means harsh shadows, they are natural and acceptable in almost all photos.

## Wait for the light

When the sun hides behind a cloud, most experts advise waiting for it to return to get the perfect shot. We agree – but take a picture first. Snap the sub-optimal shot to cover in case your scene changes, you have to go, or the sun never comes back.

If you find a particularly intriguing sight (or site), visit it several times under different lighting conditions – morning, noon, night and storm. Great photos happen in the perfect light, usually watched over by patient photographers. But you have a digital camera, so you might as well take exposures under all conditions.

## Backlighting

There are times when these simple strategies won't work – such as when the sun is coming from behind your subject and he or she isn't willing to wait while you circle round, or there isn't room to circle round, or you want to capture the moment. In such a situation (known as backlighting) there are three things to remember:

**Keep the light source out of the frame** *or cover it with your subject. The sun in your frame will overpower everything else and reduce your image to one white spot in a sea of black.*

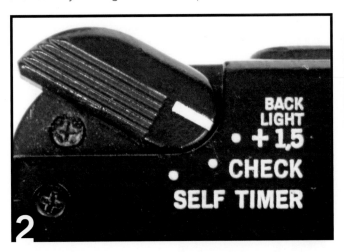

**Fill flash** *When you don't have enough natural light to compensate for backlighting, make your own. Use your camera's fill flash to lighten the shadows. For a more subtle effect, use a reflector (even a big white card) to bounce light from the sun back into your subject's face.*

**Open the aperture** *The sun behind your subject puts it in shadow, and you need more exposure to illuminate the details. Most cameras have a backlight button or control that opens the aperture by a stop or two. Two stops is often best.*

# PART  The value of tripods

Even the smallest camera shake during exposure can make
a well-focused photo look soft and fuzzy, and you must hold
your camera perfectly still to get perfectly sharp photos.
This becomes increasingly difficult in low-light conditions
when you are using longer exposures. It's on such
occasions that you need a mechanical aid of some sort.

The key tool is the photographic tripod – most digital cameras
have a tripod mount (a threaded hole in the bottom that takes a
bolt from the tripod) – but other means can be used.

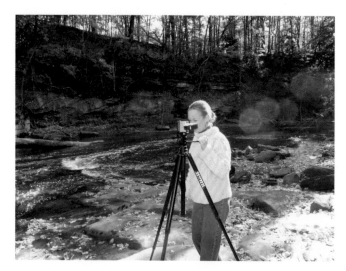

## Choosing a tripod

Finding the right tripod requires a careful examination and
understanding of what makes a tripod work. Every tripod has two
essential parts, legs and a head. In the middle you may find a
centre-post but no body.

Tripods differ chiefly in construction and size. Lightweight
tripods are easier to carry but sacrifice stability. Most are made
from aluminium but the best use carbon fibre, which shaves
weight but keeps the tripod sturdy.

You want a tripod that holds a camera at your eye level but
has legs that telescope down to convenient carrying size. The
more sections to the legs, the less stable the tripod is apt to be.
The legs of most tripods have three telescoping sections.

Tripod legs adjust for length to help you get the right height
and to compensate for uneven terrain. Some adjust with collars,
others have levers where the legs telescope. Levers are quicker
and less apt to suffer from mud and dust.

A centre-post lets you adjust the camera height after you've
locked the tripod's legs in place. The best place for the centre-
post is all the way down because it is less stable than the rest of
the tripod and apt to shake or vibrate. Use it sparingly.

### HAND-HOLDING IN LOW LIGHT

If you have to hand-hold in low light, remember the cardinal rule: the slowest
speed you should hand-hold an exposure is at one over the lens's focal length.
So, with a 50mm lens (on a 35mm camera), don't hand-hold at speeds slower
than 1/60th second. Most digital cameras know this rule, and in their program
modes will try to avoid letting the shutter speed slide down too low.
Longer exposures yield greater depth-of-field (because you use a smaller
aperture), which can help bring a landscape together. A long exposure can
also add desirable artistic effects, such as smoothing the flow of water over
rocks and waterfalls. A longer exposure might also be necessary to capture a
portrait by available light.

Collar adjusted tripod leg.

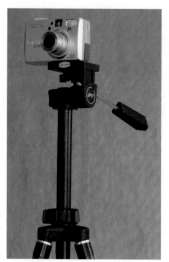
A fully-extended centre post.

Lever adjusted tripod leg.

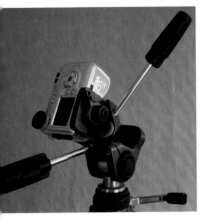
A pan-and-tilt head.

## Heads

The head of the tripod is what actually holds your camera. Its design affects how easily you can frame your shots.

**Ball heads** are the easiest to use and often the most costly. Aptly named, the ball head puts your digital camera on a ball that rotates within a socket in the head. In one motion you can aim the camera in any direction, then twist a control to lock it in place.

**Pan-and-tilt heads** give you individual control of two axes so you can separately adjust the lens up-and-down (tilt) and left-and-right (pan). If you level and orientate your tripod properly, you can adjust pan and tilt independently for perfect control, otherwise the two controls interact, and you'll spend precious seconds fiddling.

**Video heads** are pan-and-tilt heads with a difference, a fluid filling. You get two-axis control but smoother motions thanks to fluid damping. The damping adds resistance to your adjustments, eliminating any jerkiness from you pans and tilts. When used for a still camera, however, the damping interferes with the fast adjustments most still photographers demand.

A ball head.

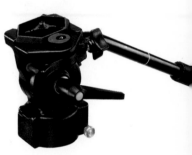
A video head with fluid filling.

## Tripod alternatives

A tripod is not the only means of holding a camera steady. You have several alternatives, some of which can be better for particular applications.

*Brace yourself. Use a handy wall or tree to help you steady yourself. The extra support can help you steady your camera at a speed a notch or two slower than ordinary hand-holding. You might even forego holding the camera and put it on a rock, if you can get the angle right.*

*Bean bag. One of the professional's favourite tools is the beanbag. It's like putting your camera on a rock, but you can shape the bag to get the right angle for your shot. Although you can buy special photographic beanbags, even one you borrow from your children will work.*

*Suction cup. You can turn a car window into a tripod with a special photographic suction cup. The cup will hold to any glass or smooth surface, and a pivot (or head) on the cup lets you get the angle. Just be sure to stop your car's engine so its shaking doesn't undermine your efforts.*

*Monopod. A monopod is lighter than a tripod and easier to carry and set-up, particularly in crowded situations where tripod legs would get in the way. Although a monopod won't steady your camera for multi-second exposures, you will gain several notches in film speed. Monopods are also useful when you use a long focal length even in moderate light.*

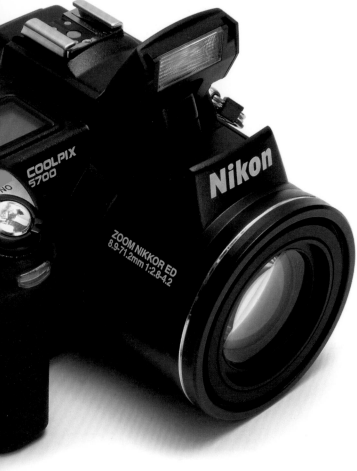

PART **5** # Flash techniques

Flash starts out as just a convenience – to make light where there is none. But it has the potential of being much more than merely a way of making a snapshot possible, and can be used as an artistic tool. Flash embraces everything from the tiny light on your camera to elaborate studio set-ups.

## On-camera flash

**Direct flash** from your camera yields flat lighting, brightening dark subjects but eliminating texture and contours. It is also the cause of red-eye. On-camera flash not only captures an image, but cages its creative potential.

**Bounce flash** is flash from your camera reflected off the ceiling or walls of a room. Its diffuse light is more natural, kills hard shadows and red-eye but lacks sparkle and definition. Some flashes swivel to make this easy. With those that don't you'll need a reflector card to bounce it twice.

**Diffuse flash** spreads the light over a larger area, softening shadows and giving a more natural appearance. The effect is in-between direct and bounce flash, softening the edge of direct flash but giving more depth than bounce.

**Ring flash** requires a special add-on flash attachment that illuminates the subject from all around the lens, totally eliminating shadows and pumping light deep into crevices and holes. Although most often used in close-up photography, some photographers use the shadow-free light to great effect.

A ring flash unit.

Flat-lit photo taken with on-camera flash.

Photo taken with bounce flash.

Photo taken with diffused flash.

Off-camera flash photo with stark shadows.

Photo with diffuse off-camera flash.

Off camera flash with diffuser in front.

## Off-camera flash

By moving a single flash off the camera, you instantly eliminate red-eye, but shadows may loom large.

**Direct flash** off-the-camera, however, gives hard black shadows hugging one side of your subject. Used wisely it can be an interesting effect, but it often looks artificial and contrived.

**Diffuse flash** from an off-the-camera unit yields the most natural effects, with softer natural shadows and even lighting. Careful positioning of the flash can enhance the features of a portrait subject.

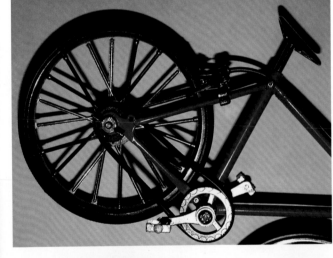

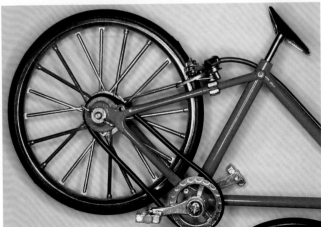

**Main light** illuminates the overall scene and ties everything together.

**Background light** illuminates the background and, often, erases shadows that would otherwise fall there.

**Rim light** shoots from above and behind the subject to outline hair and shoulder with brightness.

**Modelling lights** are small, continuously burning incandescent bulbs inside each flash that let the photographer see an approximate effect of the flash (but dimmer).

**Fill light** lowers the contrasts in the image by lighting areas in shadow.

**Key light** highlights the most important part of the subject.

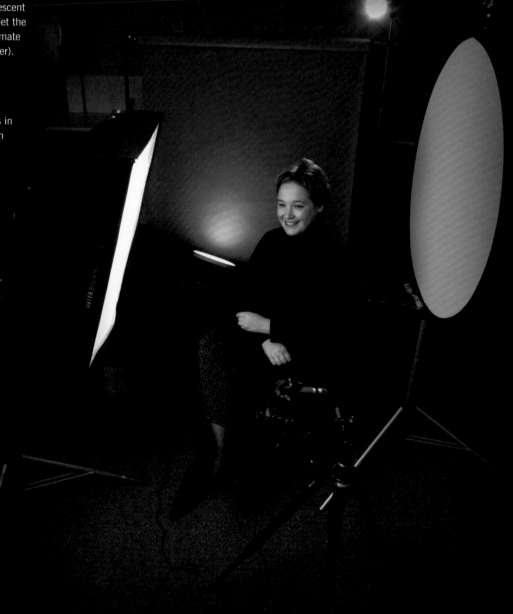

## Multiple flash

Most off-camera flash techniques use more than one flash source. Arranging the flash units is one of the most important skills of the professional photographer, and learning all the effects takes years of experience and experimentation.

The artistic possibilities are endless. For example, you can put a coloured gel (thin sheet of acetate) in front of each flash so it lights your subject in a different colour.

A pro may use from two to half a dozen separate flash units for a single subject. The most important of the sources include those shown in the studio set-up opposite.

## Triggers

In a multiple flash situation, all of the flash units must be triggered to fire simultaneously while the camera shutter is open.

Professionals use a flash contact on the camera, which provides a contact closure when the shutter opens. This closure triggers a single flash power pack that send a pulse of electricity that lights all the flash units connected to it.

**Slave units** use the light from one flash to trigger another. The small flash on your camera can trigger multiple off-the-camera flash units.

**Monolights** combine a slave trigger and a flash. Each has its own built-in power supply and plugs into the mains. You position them like a professional's flash heads. (In fact, many pros are shifting to monolights).

A slave unit. Such devices are used to trigger off-camera flash units.

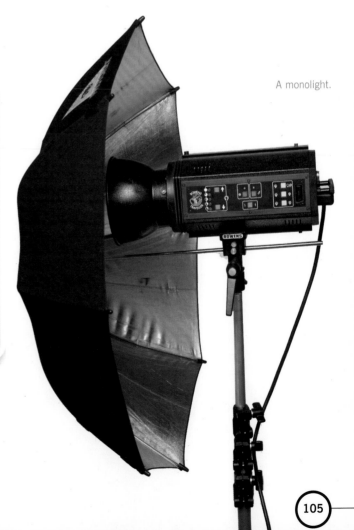

A monolight.

### USING A SECOND FLASH

You can add interest to your flash photos by using an off-the-camera flash and slave unit. Position the second flash and slave out of the view of your camera's lens. Use the second flash to one side to add interesting shadows to your subject. Put it above the subject to add rim lighting that makes your subject stand out from the background. Or put it on the floor behind your subject, pointed behind the subject, to illuminate the background and erase shadows.

PART 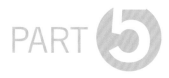 # Hot lights

Hot lights are the big incandescent bulbs used in television and film studios to light their productions. At one time, they were popular in photo studios – classic Hollywood glamour shots were all taken under hot lights – until studio flash units were developed that gave both subject and photographer more light for every exposure and cooler working conditions.

## The positive aspects
Today's digital cameras are sensitive enough to use hot lights instead of flash. You get several benefits, including:

- You see what you get.
- You don't have to judge the effects of a bright flash from small modelling lights.
- With a video monitor, you can see what your photo and its lighting will look like as you adjust the lights.
- You need only one set of lights for both still and video photography.
- There's no reason to invest in two sets of gear.
- The equipment is less expensive.
- A competent flash set-up may cost hundreds (or thousands) of pounds.
- For hot lights, you can make do with a couple of spotlights.

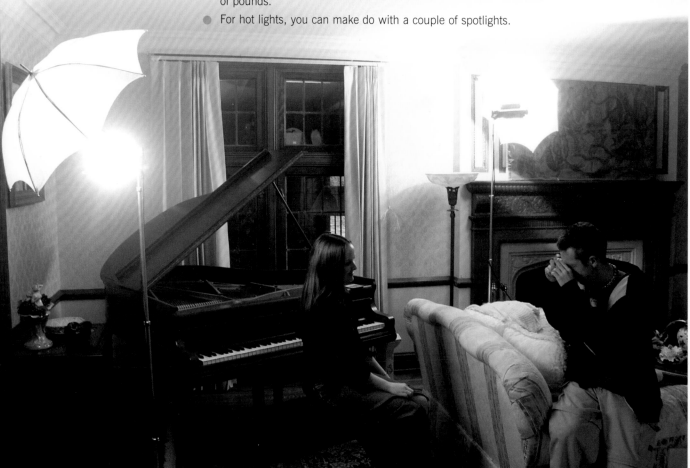

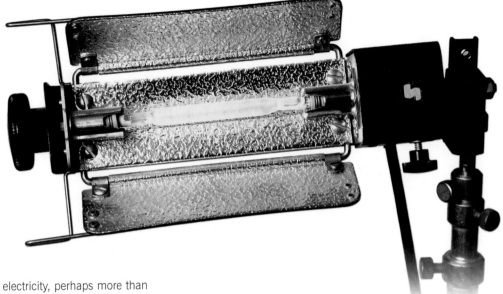

## The negative aspects

- Hot lights are hot.

- They consume a great deal of electricity, perhaps more than the outlets in your home can supply. And they can make you and your subject sweat.

- Expensive bulbs burn brightly but not very long. Photo lights have a fraction of the lifetime of ordinary incandescent bulbs and cost many times more.

- Flash units pump out the lumens. Pros often shoot at f/16 with studio strobes and get tremendous depth-of-focus. Without thousands of watts of hot light, you're apt to be shooting f/4, making focusing critical.

- With flash, pros often work without a camera stand or tripod. But with hot lights, you may want to use one for stability, to prevent camera movement from softening images and to get greater depth of field. But once you shift to some kind of camera support, you don't need the multi-thousand watt bulbs used in professional studios.

When using mixed lighting, a blue filter needs to be used with hot lights to compensate.

## How digital is different

Colour: Flashes have about the same colour temperature as daylight, so film photographers don't need to bother with filters. Flash and daylight balance out, so you can use flash to supplement daylight.

Hot lights are colder (on the Kelvin scale) than daylight. Most films require filters to compensate. Your digital camera automatically compensates by adjusting the white balance. But that won't restore the balance with daylight. In scenes with mixed lighting, the incandescent part will be yellowish, the daylight bluish. You can compensate by putting blue gels over the hot lights, warming gel over your windows, or by masking and color-correcting the off-shades with your graphic editor.

### IMPROVISE

A high-intensity reading light makes an excellent light for close-ups. For best results, put your camera on a stable stand. To avoid bending over (and possibly in the way of the light) use an external monitor to set up your shot and focus.

DIGITAL PHOTOGRAPHY MANUAL

PART 6 **Editing Your Images**

# PART  What you need

The ability to edit images easily on your own computer is the greatest lure of digital photography. Surely, with a few strokes and clicks of your mouse, you can turn a snapshot into a masterpiece? And by putting on a red leotard and a cape you can be Superman. Be real. You can touch up photos on your computer, but getting good results takes time and skill, and developing skill takes practice. The only way to do it – and get good at it – is to do it.

**An image editing program.** *You need special software to edit large graphics. Most cameras come with such applications, but sometimes you get a slimmed down version. Better programs give you more options and versatility. For example, many cameras include Adobe Elements, which is a subset of Adobe Photoshop, the professional standard.*

**Minimum computer.** *Graphic editing is one of the most demanding applications you can run on a computer, so you'll need substantial microprocessor power. The absolute minimum is a 300MHz Pentium II, but if you're buying a new machine, aim for at least a 1.6GHz Pentium 4 processor, or a Mac equivalent.*

**Maximum memory.** *Graphic editing burns up megabytes. The more memory you have in your computer, the faster your editing will be. With Windows XP, you'll want at least 256 megabytes for graphic editing, but aim for 512MB.*

**Pointing device.** *Graphic editing requires precision, speed and endurance in moving your cursor around the screen. You'll want a pointing device that's comfortable for long periods of use and precise in its capabilities. Although an ordinary mouse may suffice, a trackball may work better for long sessions.*

## WEB RESOURCES

Ask anyone about image editing and they will tell you the software you need is Adobe *Photoshop*. Certainly *Photoshop* is the package the pros use, but you'll likely pay more a copy than your digital camera cost. Most people don't need all of its power. For under £100 (and often £50) you'll find a wide array of photo editors aimed at the hobbyist.

**Adobe** *Photoshop Elements*, www.adobe.com/products/photoshopel/main.html
**ArcSoft** *PhotoStudio*, www.arcsoft.com/products/software/en/photostudio.html
**Corel** *Photo-Paint*, www.corel.com
**Jasc** *Paint Shop Pro*, www.jasc.com/products/psp/
**Microsoft** *Picture It Publishing Platform*, pictureitproducts.msn.com/default.asp
**Microsoft** *Picture Publisher*, www.microsoft.com/office/publisher/evaluation/trial.asp
**Roxio** *PhotoSuite*, www.roxio.com/en/products/photosuite/index.jhtml
**Ulead** *PhotoImpact*, www.ulead.com/pi/runme.htm

# Monitor calibration

Much of photo editing is based on the What-You-See-Is-What-You-Get, or WYSIWYG, principle – what appears on your monitor should accurately represent what comes out of your printer. More important, what you see on your monitor should be the same as what everyone else sees on his monitor. However, individual differences between monitors can result in the what-you-see being darker or bluer than what someone else sees.

For consistency between different media and different systems, you should always calibrate your monitor. Calibration sets your monitor to an objective standard that matches the look of other calibrated monitors and printers.

The process is a lot like an eye-test – which is sharper, A or B? – but you judge brightness, greys and colours. For example, with Adobe's Gamma utility, a 'wizard' walks you through a simple procedure that involves only your hand on monitor controls and the keyboard. You need no special reference samples.

**Quality monitor**. *You'll want a high-resolution monitor (at least XGA resolution, 1024 x 768 pixels) with a large screen, at least 17in diagonally. Although LCDs are compelling, CRT-based monitors have the edge in precise colour – CRTs still display more colours than LCDs for critical applications.*

## WHAT'S GAMMA?

Gamma is the mathematical relationship between two tone curves. It has different meanings in photography and electronics. In photography, gamma represents the relationship between the tones of the subject and those captured on the negative. In electronics, gamma is the relationship between the voltage controlling a monitor display and the brightness shown on that display. The visual effect of gamma is a change of contrast. The gamma correction applied in monitor calibration instructs your computer to alter the signal it sends to the monitor to help make the changes in video signal voltage better match the changes of brightness on your monitor screen.

# PART  Take it step-by-step

You can edit any image and adjust any part of it any way that you want. But following a step-by-step procedure every time makes your effort routine – and makes you less likely to err. You can work in any order that you want, but you'll minimise your mistakes and maximise your use of time by taking your steps in the following order:

**Select your pics** *The first step in improving your photographic results is learning to be selective – become ruthless in choosing which photos you keep and which you discard. Out go the finger-on-the-lens, out-of-focus, and headless-aunt shots. If however you're undecided back-up all the raw images from your camera onto CD so you can retrieve them if needed.*

**Keep a copy of the original** *Keep a copy of your original photo somewhere safe, preferably on a CD, so you know it won't change and you can always return to it if your editing goes awry. You can replicate the editing, but you may never be able to take the original photo again.*

**Save multiple copies** *Save multiple copies as you go along. You will make mistakes and you'll want to go back to an intermediary stage in your editing. If you keep multiple copies under different names – Birthday Photo 1, Birthday Photo 2, and so on – you can step back in stages to avoid having to duplicate your editing when undoing your work becomes impossible.*

Each layer holds part of the picture. These are combined on top of each other like virtual sheets of acetate to build up a photo. Here five layers were combined to make the composite.

### 4 Working in layers

*Although most photos need only one or two changes to fine-tune them, some may require more elaborate work – work you don't want to waste should a subsequent adjustment go awry. To help you cope with more intricate jobs and give you greater versatility, some photo editors let you work in layers. You can make several layers from one photo image and work on a single correction in each. When you're satisfied with the results, you combine them back together. An error or change in one layer won't affect the others, so you can tinker with your image without worry about ruining your previous work.*

### 5 Fixing backgrounds

*The background is the largest or second largest image area in your photo. Make sure you can save it and that it will make your photo work. (see page 114)*

### 6 Touch up the details

*Take an overview of the full image, then enlarge critical details. Fix the small things. (see page 116)*

### 7 Crop the image

*Once the editing is done, you can trim the size of the image and make the rest of your changes go faster. Cropping now will also prevent areas that will be unseen from affecting colour and contrast adjustments. (see page 122)*

### 8 Adjust brightness and contrast

*To make the best use of the medium, use the full tonal range of the digital code. You can still mask to locally change image contrast and brightness. (see page 124)*

### 9 Adjust the colour

*Although colour, brightness, and contrast interact, you'll get the fewest surprises if you save colour correction for the last. (see page 126)*

### 10 Adjust image size and resolution

*Once you've got your photo into shape, you can shrink it to fit where you're going to use it. Reducing the size now will make your editing less noticeable. (see page 128)*

# PART  Fixing backgrounds

The camera is an all-seeing eye, one that can see too
much, and sometimes you just want to go back and take
the picture again – difficult when your photographic
subject is now at the other end of the country.

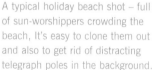

A typical holiday beach shot – full
of sun-worshippers crowding the
beach, It's easy to clone them out
and also to get rid of distracting
telegraph poles in the background.

Too often a perfect picture – a moment you want to remember
forever – gets spoiled by background intrusions, things you wish
just weren't there: wires, a discarded carton, a wayward flying
saucer. You could cut the offending part out of the picture, but
there's a problem. Whatever you remove from an image leaves a
blank space that must be filled with something. Ideally you'd
have another shot of the same scene without the intrusion so
you can cut-and-paste the exact piece you need. Most of the
time, however, you're stuck with one photo and the need for
repairs.

Photo editing software lets you duplicate part of the image
from elsewhere to fill the void left by what you remove. The
process is called *cloning* because you make an exact copy of
part of the scene from another place. You only need to indicate
the area containing the fill material to be cloned, then place your
cursor on the intrusion into your image. Click, and the clone
covers up the irritation.

The easy description belies the artistry required. To make your
repairs unobvious, you need to match the colour, tone, lighting
and texture of the area you're covering up. You also need a deft
hand to avoid covering any of the image you want or making
obvious editing marks. In other words, it takes practice.
Fortunately for the impatient learners among us, Nature is
forgiving, and when you want to fill with ordinary background,
matching is amazingly easy and real skill comes quickly.

# Step-by-step

**1** Choose a brush or tool shape. For natural background, select one with a soft edge; use a hard edge only when you need to trace the exact shape of an object.

To choose the tool using Photoshop Elements, *left click on the Clone tool and select the size of brush appropriate for covering the intrusion with several strokes.*

**2** Find an area on your image with a background matching that behind the intrusion in colour, texture, lighting and content, then select the area for cloning. In Photoshop Elements, *for example, hold Alt while clicking on the area to be the source of the clone.*

**3** Place your cursor over the intrusion, and left click to cover it. Use the cursor as a brush to paint over the intrusion. Be careful to stay within the bounds of what you want to replace. With a feathered-edge tool, work from the centre outward. With a sharp-edged tool, work from the edge inward.

**4** Now that there's no gate, the balance has changed so the photographer removed the blank area on the left of the picture using the crop tool.

# Tricks of the trade

*Tip 1* When covering a shaded texture, cover an intrusion by working both ways from the edges to the middle. This strategy minimises your chances of creating a sharp edge where your cloning ends.

*Tip 2* If you can't seem to get an edge right or you accidentally create an edge where one should not be, you can cover it up with the *smudge* or blending *tool.* Work in both directions to blend the edge away.

*Tip 3* Work big. A steady hand is a virtue but hardly necessary when you can pick a pixel at a time. Although altering a large background will take you longer when you magnify each section and use small tools, you'll suffer less frustration and fewer mistakes.

PART  # Touch up the details

The details make the photo work. Little things that might not seem to make much difference stand out as sore points in otherwise great photographs. Taking a bit of extra time for making the details right will pay off in both your own satisfaction and the compliments of the people who see your photos.

## Red-eye

Despite the name, the red-eye phenomenon can show as yellow, or even the evilest of greens. Fortunately, it is such a common problem that most photo-editing programs make fixing it a standard feature, just as you could buy special 'red eye' pens to fix film photos. The process is easy. Simply black out the glow, and the character of your photo immediately changes. Your relatives look human again, no matter how they behave.

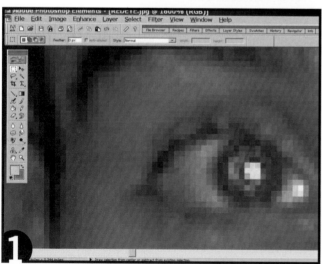

*Zoom in on a glowing pupil. With most red-eye cases, you'll want to be able to see individual pixels.*

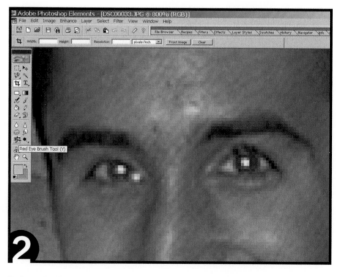

*Select 'red-eye' mode, if your software has one. Otherwise, choose 'image cloning' (as a brush type, for example, in Corel PhotoPaint).*

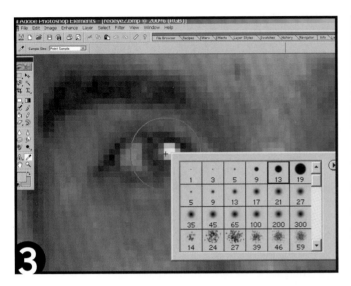

**3** Select a round brush with little or no transparency. Adjust the size of your brush to fit over the glowing pupil.

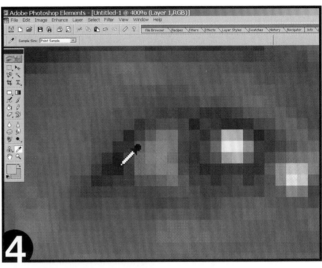

**4** Use the eye-dropper tool to select a dark pixel, nearly back, from near the eye, a shadow in a corner of the eye often works. Be sure to choose a tone that matches the overall picture – a warm dark grey for a warm-toned photo.

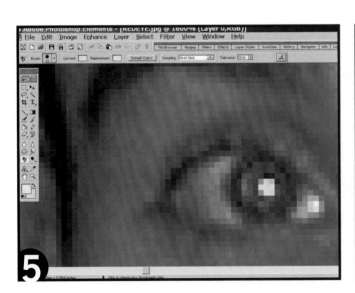

**5** Right click to paint the pupil. If you've chosen the brush size correctly, the entire pupil will paint at once. If not, clean up any remaining red-eye pixels.

**6** Pull back and check your work. You can also use the 'undo' function and try again if the colours or brushstrokes don't work.

## DON'T USE BLACK

We all know that the pupils of everyone's eyes are black, so why not just choose black to eliminate red eye? The results speak for themselves. Try it, and you'll get pupils that are as unnaturally dark as they were unnaturally glowing before.

In photos, pupils are rarely a pure black. There's always a bit of reflectance from the eye that brightens things up and may even add a dash of colour. Shadows elsewhere in the photo likely reflect less light and are naturally darker.

Choose the colour to paint in pupils carefully, and your photos will look more natural than they came from the camera.

## Cloning and masking

Advanced photo editors let you clone part of images, which allows you to cover up out-of-place intrusions in the background or correct for errors in composition. You can eliminate overhead wires or even supernumeraries in family photos.

One of the primary tools in most photo editors is the mask, which lets you limit the area upon which you work to a small portion of a photo. For example, you can selectively soften a portrait while retaining sharp focus on the eyes. Masks also let you move photo elements around or even add part of one photo to another.

## Combining pictures

*Mask your subject, either by hand (drawing around it) or with one of the tools offered by your editor. Then cut or copy your subject from the original image.*

*Select your background. Adjust its colours and focus to match your subject.*

*Past the subject in place.*

*If necessary, smudge the edges of the mask to blend in the subject or clone a few pixels.*

*If you move the subject within an image, you'll have to clone some background to replace where your subject originated.*

*Apply an overall effect to blend the subject and background together.*

# Transplant tips

You can put yourself (or anyone) right in the middle of things anywhere in this world – and places far beyond – with your photo-editing software.

Fakes though the results may be, it's fun to share them with your friends. If you want to make them take a second look, however, you'll need to make your work as invisible as possible. Follow our tips, and they will find it difficult to tell.

***Be careful about the colour***. *Every subject has a colour cast, and if the subject and background don't match, your handiwork will be obvious. If you see a wide disparity, adjust the colour with your editor to make the hue match in both your subject and background.*

***Tweak the sharpness***. *Although the sharpness of every part of a photo is not the same, your eye can tell instantly if something is amiss. The focus of the background and foreground may (and often should) be different, but if your subject is soft yet its edges sharp where you cut your mask, your illusion won't work. Your eye will also spot where the camera moved in snapping your subject but not the background.*

***Watch the light***. *A difference in the feel of the light on your subject can make it stand out from the background. Ensure the quality of light matches. If the light is harsh from bright sun on your subject, it should be harsh in the background. If the light on your subject is soft and diffuse, be sure your background was photographed on an overcast day.*

***Watch the shadows***. *The wrong shadows – or worse, no shadows at all – will make any added subject look alien to your photo. Ensure your subject is lit from the same direction as the background and at roughly the same time of day so the lengths of shadows match.*

***Work big***. *Even if you plan to post the final image on the Web, work at the highest possible resolution. When you reduce your finished image to fit its final resting place, you'll also shrink all of the telltale signs of your tinkering.*

# Artistic effects

Photos are documents and evidence, but at some point you may tire of trying to mimic reality and want to take a side trip to artistry. You photo-editor makes it easy. Most give you a wealth of artistic effects that let you turn an ordinary snapshot into an eye-catching picture or poster.

What you can do is limited only by your imagination and the features of your photo-editor. Some allow you only to adjust brightness, contrast and size. Most, however, let you change aspect ratio, distort image shapes, change colours and add textures. You can spend hours experimenting and you should – there's no better way of mastering the effects.

The mechanics of this kind of manipulation are easy. Select the effect, preview it, then click OK. If you don't like what you get, undo and do again. Most effects can be constrained to a mask, so you can make part of your image stand out, say draining all the colour away from the background. Our illustrations are only suggestions to tempt your imagination.

**Drawing tools** Many photo editors come with a full array of drawing tools, so you can add artwork to your pictures or draw in missing pieces. You can add your own frames or let your creative streak run wild.

**Text** You can add text – either to personalise photos or make them more meaningful (for example, adding captions) when your photo editor has text abilities. The best programs incorporate many of the features of word processors, including spell-checking, as well as a wide variety of fonts.

*Choose the photo you wish to manipulate. Select an artistic filter from the pull-down menu.*

*Adjust the parameters of the filter, observing the effect on the image or preview. The correct setting is the one that looks best to you.*

*If you're not happy with the image, save it anyhow, then try another filter.*

*Each artistic filter can give an entirely different look and mood to your photos.*

# PART  Cropping

Cropping is trimming your image, cutting off unnecessary parts that either waste paper or distract attention and offend aesthetics. You can consider it moving the borders inward. Cropping is the most basic form of editing an image, but also one of the most effective.

The photo you take is a raw image. Try as you may, you probably cannot frame exactly what you want because you can't get close enough, or something interferes with your view, or you just didn't see something and got the balance all wrong. Cropping corrects such errors.

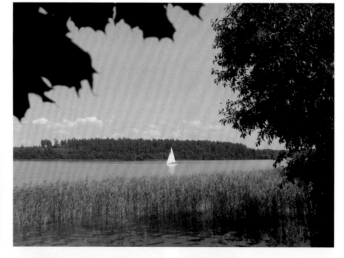

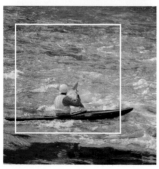

**Cropping for impact**
*By eliminating unnecessary parts of a photo, you focus attention on what you want to get across. A face may be lost in a crowd, but you can make it the centrepiece by cropping the image. In effect, cropping can be after-the-event (and after-the-photo) digital zooming.*

**Cropping to fit a format**
*The format of your camera's pictures may not match the size of print or space for a photo in printed material. You have to trim off one side or the other to make the image fit. By cropping before printing, you rather than the printer decide what to omit.*

**Cropping to alter format**
*Sometimes you take a portrait with the camera aimed for a landscape or vice versa. You can crop your image into the format you prefer.*

**Cropping to eliminate extraneous elements**
*The easy way to eliminate something you don't want in a photo is to crop it out. Just trim your image a bit and remove branches, appendages, or thumbs-on-the-lens that intrude into your image.*

# Step-by-step

*When you crop, the mask is your friend. Pick the rectangular mask.*

*Position the cursor in one corner of the area you wish to remain after you crop, then click to anchor the mask.*

*Move the crop to the opposite corner of the area to remain.*

*Check the dimensions of the area (if they are critical). Your editor may show you the starting and ending co-ordinates, or the delta, the difference between them. If necessary, adjust the cursor until the area is correct.*

*Left click again to lock the mask in place.*

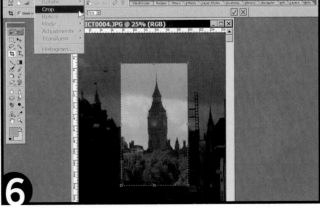

*Click the 'Crop' command.*

# PART ⑥ Brightness & contrast

The basic changes you're apt to make to a photo involve
the entire picture – for example, correcting for a too dark
image. Most photo editors make such corrections a
simple, interactive process. Choose what you want to
change, make an adjustment, and see the effect.

Brightness and contrast. The most common photographic problem is
improper exposure, a shot that's too light or too dark. Photo editors
allow you to adjust the brightness of each image as well as tweak the
contrast so you use the full range of available tones.

Some photo editors take you a step further. For example, to set
the optimum range between the brightest and darkest tones in a
picture, they include an Auto Equalize function (or simply
Equalize function – terminology varies).

Although these controls make automatic corrections, they are
not automatically correct. For example, the mood of a photo may
demand that you don't use the entire tone range available, so you
may want to skew it towards the dark side.

If you're not quite sure what photo parameters to change,
better editors will show you a sample of the available
adjustments and their effects – Adobe Photoshop calls this
feature Variations. Pick the version that brings your image closest
to perfection.

# Image correction step-by-step

**1** *Load your image* into your photo editor using its File, Open menu selection.

**2** *Select the brightness & contrast* from the repertoire available in its menus.

**3** *Correct the image* by adjusting the slider or changing the numerical value displayed by the photo editor. You should get either a thumbnail or full-screen preview of your change.

**4** *Click OK* when the preview looks best, and your photo editor will calculate the changes for every pixel and display the new image on the screen.

**5** *Use the Undo* function to step back from your change and try again. Every change is not always successful. Digital technology gives you a second, third and fourth chance.

# PART ⑥ Colour & sharpness

## Colour correction step-by-step

Although most digital cameras automatically correct for most lighting situations using their automatic white balancing function, your images may sometimes have an odd colour cast. Colour correction adjusts the relationship between colours to seem more natural and eye-pleasing.

*Choose the colour correction function in your photo editor. Depending on the editor you use, this function may be called colour balance or colour correction and may be found under the image adjustment or enhancement menu selection.*

*The easiest-to-use editors require only that you select a white or grey patch in your image (shown here using the eyedropper as a cursor). Choose something you know should be white. It doesn't matter how large an area you select or where it is.*

*If you select preview mode, you'll see the results of your changes as you make them. If your photo still looks odd, you can select a different white patch.*

*Click OK, and you're finished. You can also use the colour correction function to dramatically alter the colour cast of your photos by choosing a coloured patch instead of a white one for your sample.*

*Manual correction: Some graphic editors give you manual control of each of the primary colours. With them, you correct the colour cast of your photos by tuning in more or less of the offending colours until the preview image looks best to your eye.*

## Sharpness enhancement step-by-step

Sometimes your photos aren't as crisp or sharp as you like. Digital photo editing gives you a means of improving image sharpness. Although no photo editor can add new detail to your images, an editor can make your photos appear sharper by enhancing the edges of shapes in your images.

*Most photo editors provide an easy, one-step automatic function to enhance image sharpness. Start by opening the image you want to sharpen. With automatic enhancement, you can work with your image at its normal size.*

*Select the Sharpen function from the menu system. You may find it under Adjustments, Effects, Enhancements, or Filters. Often you'll have a selection of several menu selections (or algorithms) for sharpening your image. Each has its own effect, so experiment.*

*Once you make your selection, your photo editor will quickly make the sharpness adjustment. If you don't like the results (often sharpening a photo will increase the noise or snow in your image), make good use of the undo function.*

## Manual adjustment

*You can often get more pleasing results by manually adjusting the parameters used by the sharpening algorithm. To better gauge what you are doing, enlarge your photo so the unsharp edges become readily apparent.*

*Your photo editor will allows you to adjust several parameters used in tuning the sharpness of your image. Experiment with each adjustment, observing your results in preview. The correct sharpness setting is subjective, typically a balance between enhancing edges and accentuating the grain and noise of the photo.*

# PART 6 Altering image size

Size matters, particularly when it comes to fitting an image onto a web page. Paste a picture straight from your digital camera onto your home page, and every visitor to your site will be brewing a pot of tea (maybe even harvesting the tea) while waiting for the page to load. Similarly, you don't want wallet photos to amaze your friends that you have to unfold like a roadmap.

Size is actually two issues which depend on how you measure. The size of the photos you print is an issue of actual image size. The size an image appears on the Web is more a matter of dots and resolution. The JPEG file format used by most digital cameras stores this information separately. Which way you measure (and tinker) depends on what you want to do.

## Image size

The image size is the measurement of how large your picture will appear on paper, measured in centimetres or inches (depending on your preference). Adobe calls the image size the 'document dimensions'. When you print a photo for an album, for a frame, or for your wallet, you want to alter its size to fit.

When you specify dimensions to your image editor, it adjusts the linear dimensions of the image. Depending on your editor, this may also alter the resolution of the image. Generally, that's OK. You will preserve the detail that your camera put into it.

## Dot count

Putting a megapixel image on the web is like fitting a rhinoceros into your back pocket – a big challenge with a dubious reward. You need to reduce the number of pixels (yes, the ones you paid extra for when getting a higher resolution camera) for web-based applications. Adobe calls the dot count the 'pixel dimensions' of the image. The resolution isn't an issue because it's set by the monitors of the visitors to your website.

You adjust the size that an image will appear on a web page by adjusting the dimensions as measured in dots or pixels. The centimetres or inches don't matter at all.

Of course, not everyone uses the same resolution or window size for browsing. The safe measure is to assume a VGA image is full-screen and should be the largest image size you use. Quarter-page (320 x 240 to 512 x 390) and smaller images are usually sufficient for most web pages. Smaller, of course, means faster loading.

## Image size versus canvas size

The image size describes the dimensions of the image of your photo. The canvas size, or page size, describes the sheet on which you want to print the photo. Normally the two are the same. Increasing the canvas size without changing the image size will add a border around the image.

Although the canvas size is essentially a command to your printer, it changes the stored image, adding a border around it and increasing the overall dimensions.

Most editors allow you to change the colour of the canvas and place your image anywhere upon it. Reducing the canvas so that it is smaller than the image will clip or crop the image to fit.

## Resampling versus resizing

With most image editing programs, resizing an image does not affect its resolution. That's OK most of the time when you want to reduce the size of your picture, but when blowing up an image, big pixels means rough edges. Smooth lines become jaggy.

To relieve some of the jaggedness, choose to resample the image. This operation forces your graphic editor to interpolate pixels and smooth the lines and edges of images.

Simple resizing results in apparent image raster. Resampling smoothes edges.

## Step-by-step

Open your image and choose to resample or resize the image.

Your editor should tell you the current dimensions of the image, both in pixels and linear measurements.

Choose the new measurements. To preserve the shapes in your image, check the box to keep the same aspect ratio or proportions.

Click OK, and your image will be resized.

# PART 6 **Altering image resolution**

In a modern computer, resolution changes nearly everywhere, automatically and invisibly. Only rarely does the number of dots on the screen or on paper correspond exactly to those created by your camera. Nearly every step along the way, your computer alters resolution for one reason or another. For example, the number of dots produced by your camera, the dots displayed on your monitor screen, and the dots arrayed on your printouts are rarely all the same.

Your eye may tell you that more is better when it comes to resolution. More dots means greater detail and image sharpness. But resolution isn't such a simple issue. Higher resolution can sometimes result in lower image quality. Interpolating an image, for example, adds dots but no new detail. Moreover, high resolution brings its own penalty. What pleases the eye often stretches your patience. The more dots in an image, the longer everything you do with it takes, from downloading it from your camera to printing it out.

## Select at the source

When your camera gives you a choice of resolutions, choose the one closest to the resolution with which you want to work. Manufacturers assert that their interpolation algorithms work better with the images made by their hardware. (Scanner makers are particularly adamant about this, which is one reason they give the choice of so many resolutions for your scans.)

Remember, the quality choices offered by most digital cameras – such as normal, fine and very fine – usually change compression without affecting image resolution. You may lose sharpness by opting for lower quality, but the number of dots in the image does not change.

Some cameras may have an 'economy' mode that produces VGA-quality images (640 x 480 pixels or a scant one-third megapixel) that save memory and may be just right for images bound for posting on the Web.

## Matching your printer

Printers promise high resolutions, often 1200 to 1440 dots-per-inch. Don't be misled into thinking your photo images must match your printer's resolution. Too many dots will make a huge image your printer cannot handle. Printers use much of their resolution for dithering. That is, each dot from your photo is printed using a matrix of several (or dozens) of ink drops of different colours. Although there is no magic number for the best match between your image and the printer, most people choose 300 dpi for printed images. The printer's software driver selects the resolution and dithering based chiefly on the kind of paper you tell it you're using.

## Photos embedded in web pages

When you plan to publish on the Web rather than on paper, the total number of dots rather than dots per inch is the more important figure. Size your images to fit your on screen page, for example 320 to 400 dots across to spread across half a web page. Adjust the resolution of your images before you insert or paste them on the page.

Although today's web creation software gives you sizing options for your images, allowing you to adjust how they will appear on the screen, these settings do not change the actual size of the image files that must be downloaded from the Web. Specifying a small display size for a high-resolution image will force those visiting your page to wait for details they don't need to download. Use your photo editor to reduce the image size to what fits on your web page.

Note that Macintosh computers standardise on-screen images at 72 dpi for a consistent look between monitor displays and printed images. For Web displays (which might appear on any size screen at any resolution), this figure is irrelevant.

## Photos embedded in documents

When you plan to place an image in a document you will later print yourself, use the high-resolution version of your image. Specify its size using your word processor's controls for dimensions and placement. Typically, you can right-click on the image for a menu of image size and placement options. Keeping the image large gives your printer the most detail to work with and can result in better on-paper quality. The additional time required for saving and retrieving the image will be only a small penalty when you only need to read and write your hard disk drive.

If you are sending your files out to be printed elsewhere, check with the service bureau to determine their preferred image size and resolution. Most prefer an image resolution of 300 dpi.

## Step-by-step

*Open your image and choose to change resolution. Or, if your software lacks the option, to resample or resize the image.*

*Your editor should tell you the current dimensions of the image, both in pixels and linear measurements.*

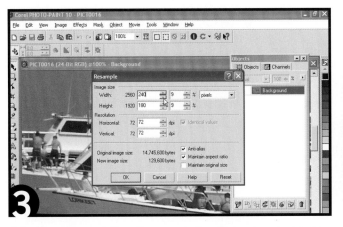

*Enter the new resolution. To preserve the shapes in your image, check the box to keep the same aspect ratio or proportions.*

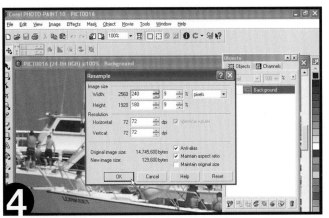

*Click OK, and the software will recompute the resolution of your image.*

7

PART

# Exhibiting and Exchanging Photos

# PART  Printmaking

The photographic print, where all your investment, skill and luck come together, is the hard evidence of your work as a photographer, the undeniable result of all you do. It is the image made real, on paper, something you can keep and display, give away or even sell. It is why you buy a digital camera.

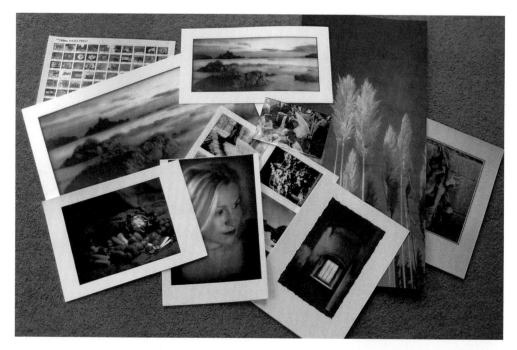

The photographic print is also where all of the latest image-making technologies come together to produce something that looks like the product of decades-old technologies. In digital photography, printmaking is nothing like chemical photography – and that's good. Developing and printing film was one of the most exacting, painstaking and frustrating tortures amateur photographers routinely submitted to.

Certainly, some of us actually liked watching images appear as we dunked our hands in tanks of hydroquinone and metol – at least until we discovered the toxicity of the chemicals, which is especially severe in those used for colour. In digital photography, however, printmaking is non-toxic. Better still, unlike making chemical prints, digital printmaking is entirely repeatable. Every print will be the same – at least until you run out of ink. It is not temperature sensitive, and you don't have to do it in the dark.

That said, some enterprising marketers know that the traditional way of sending out film and getting back prints is now part of our collective soul, so they've gone to great effort to make digital printmaking a familiar experience. At the other end of the spectrum, digital can do away with the photographic print entirely. In between are several alternative methods of handling the images your digital camera makes.

## Let Kodak or a local photo-finisher do it

The easy way to handle your photo printing needs is the old-fashioned way – pass the project along to the professional. Choose wisely and you'll get the best quality prints, analysed with the same equipment that handles real film negatives and printed with the same photographic materials. You can post your digital images or drop them off at your photo processing shop (check the digital format that your photofinisher will accept).

On the downside, you'll also pay for what you get. You pay for the materials at whatever rate the photofinisher chooses to charge and you pay for the professionalism.

## Do it on the web

You can whisk your photos out in digital form to an on-line service bureau – digital photo images will flow through the Internet as easily as any 100,000-page document. You simply upload your photo files to a web-based service, and they mail prints back to you. With an on-line service, you get the same quality as with a local professional (at least in theory) and may find a better deal, although there's no guarantee the Web will be cheaper. Digital makes it easy to keep a spare copy of everything you send in, so there's no risk of losing irreplaceable negatives to bumbling on-line oafs.

On the downside, you send out at the speed of light, but your photos come back with the speed of the post. But you can send your photos off while you're on holiday and have them waiting when you arrive home – just like film.

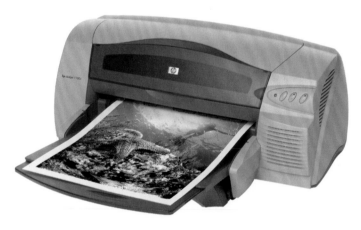

## Make your own prints

Even an inexpensive modern inkjet printer can make photo-quality prints to your precise specifications. You have full control of size, quality and delivery of your prints. You also save the costs of having someone else do the work – at the price of spending your own time shepherding out the prints. Surprisingly, it takes about as long for an inkjet to rattle out a photograph as it did for one to develop in a tray.

You'll be surprised at another similarity – the cost involved. For reasons known but to supply-and-demand curves, if you pay list price for paper and ink, making a digital print is about as expensive as doing it through chemistry. With careful shopping for supplies, however, you can trim the cost of printing your own pictures by half, making it much less expensive than commercial photofinishing.

## No prints at all

Digital is an ephemeral medium, and that's good. Most of the digital photos you take never need to appear on paper. Ruthless editing will see to that, but even those you keep may be happy to forever stay in digital form. You can view them on the computer or video monitor whenever you want without having to find a storage space for them.

You can publish your images on CD or DVD, perhaps making your own travelogue with a digital slide show. You can send your photos to friends and relatives in disk form. Or simply e-mail them to share a special event while it is still a warm memory. Post them on your web page to let your acquaintances browse at their leisure. Anywhere your data goes, images are sure to follow.

# PART  Inkjet printers

Today's top-choice for printing digital photos is the inkjet printer. Most photo-printers use inkjet technology, and little other than name distinguishes them from other inkjets. Nearly all of today's inkjets produce acceptable photos. In fact, the biggest differences you'll see in the print quality of snapshots result from your choice of paper rather than the printer.

A wide carriage printer.

At the professional and high-end amateur level, you'll find few significant differences between inkjet printers. Size is the biggest deal, but when you pull out the eye loupe or the colour chart, you'll see some machines render better images with better colour fidelity. The differences are subtle and may be unimportant for everyday work.

Inkjet printers are so inexpensive that computer sellers sometimes give them away as incentives. Printer makers make up for these low prices by selling ink as if it were a rare medical potion – the going rate is several thousand pounds per gallon (it's sold a few cubic centimetres at a time in cartridges). Photo-quality paper is similarly outrageously priced, so an inkjet print costs as much as or more than making a conventional photographic print at home. (But it's still cheaper than having professionals make photo prints.)

## Technology

Modern inkjet printers have precise mechanisms allowing dots to be placed as closely as 2,880 per inch (about 57 dots per millimetre). By printing closely spaced patterns of a few primary colours, a process called dithering, an inkjet printer can produce nearly any colour. The dots are nearly as small as the grains in conventional photographic paper, so they rival conventional colour prints in quality.

Although you'll find slight differences in how different manufacturer's printers fling ink at paper, all produce similar results.

## Size

Inkjet printers work one line at a time and can put nearly any number of lines on a sheet. As a consequence, some models can produce large images many feet or metres long if you have the right paper and software. You can easily print huge panoramas.

Printers differ in carriage width, which determines the widest sheet you can use. The least expensive machines are meant for A4 sheets (210mm x 297mm) which can handle prints a bit larger than conventional 10in x 8in photographs. The next increment up takes you to A3-size printers for sheets of 297mm x 420mm, good enough for 14in x 11in prints. Commercial model printers have carriages up to two metres wide for making posters and other large images.

A narrow carriage printer.

A colour inkjet cartridge.

## Colours

Most modern inkjet printers use four colours of ink, three primary colours (not the primaries you were taught in school – blue, red and yellow – but the process primaries: cyan, magenta and yellow) and black. To give a greater, more realistic colour range, many photo-quality printers use six colours, adding two (such as orange and violet or light cyan and light magenta) to the standard repertory. For the best prints, you'll want six colours. Strangely enough, six-colour cartridges tend to be no more expensive than the four-colour variety.

## Resolution

As with cameras, the resolution of an inkjet printer, measured in dots per inch (dpi), translates into sharpness. In theory, a 1,440dpi printer is sharper than one rated at 1,200dpi. In truth, you'd be pressed to see the difference. Dithering makes colours with patterns of dots, usually a large array (five by five dots or more), and the effectiveness of the dithering has more impact on quality than does the physical resolution of the printer.

In practical terms, the driver software of the printer (which actually affects the dithering) has the greatest effect on print quality. No matter. Judge a printer by actually looking at the quality of its output.

High magnification showing inkjet dots.

## Interface

The interface is the connection you use to plug in your printer. For connecting with your computer, two schemes are popular, the parallel port and USB.

Parallel port is the classic printer connection with a thick cable and big connectors. With the right cable (which often does not accompany a new printer), the connection is quick and trouble-free. Look for a cable that claims to meet the IEEE-1284 standard.

USB is the modern choice. A slender cable connects your computer (or a USB hub) to your printer. It's even easier to use than a parallel port and eliminates some of the hassles that pop up with the older port. Use it if you can. If you need a cable, get one that meets the USB 2.0 standard.

Parallel and USB connectors.

## Direct control

Some new printers designed specifically for photos offer direct controls so you can print without the need of using your computer. You can slide the memory card from your computer into the printer and make size and resolution adjustment on the printer itself, printing the equivalent of an entire roll of photos in a few minutes without the hassle of copying or editing files.

# PART  Other printers

You can make photographic prints with any graphics-capable printer, including that old dot-matrix machine on your cupboard shelf that sounds like a World War I dogfight when it goes to work. For cost and quality reasons, you're better off with an inkjet printer, but an array of other technologies will work for some special applications – and when you have no choice.

When the inkjet printout on the left is magnified, the grain-like dots caused by dithering are readily visible.

A laser printer.

## Laser printers

Laser printers use toner, a dry pigment, that gets fused to paper from an image drum using heat. Both monochrome (black on white) and colour laser printers are generally available. Black-and-white laser printers are inexpensive and offer high-quality text output at low costs per page. Although they cannot produce photos even approaching the quality of good prints, better lasers produce top-quality newsletters with good halftone prints (like those in newspapers).

Colour lasers add a full spectrum to the capabilities of the laser. Although the printers themselves are expensive (£1,000 and more), they produce colour pages more cheaply than inkjets but, whilst offering high resolution, their pages don't look photographic. The toner lacks the depth of real photographs because it sits atop the paper instead of sinking in. Moreover, you can't use glossy photo paper with any laser printer because the deep coatings that give the paper its gloss will melt inside the laser printer, gumming up the works.

Laser printers are more limited in the paper sizes they can use, compared to inkjets. No page can be longer than the circumference of the laser's imaging drum. Small sheets may elude the paper-feed mechanism.

## Photo printers

Take a second look at any printer labelled a 'photo printer'. Because of the popularity of digital cameras, many companies now put the 'photo' label on run-of-the-mill printers. Although at one time this designation made a difference, today most photo printers are conventional inkjet printers that have, at best, been modified to limit you to smaller sheets like those of the popular photo formats.

On the other hand, some manufacturers have added new interfaces and control intelligence to the printer they label with the 'photo' designation. Some of these photo printers are specially tailored to particular camera models to offer you a complete 'photo system'. These allow you to plug your digital cameras directly into the printer and download images without the involvement or intervention of a computer.

That's great if you fear computers, but you lose the ability to edit and improve your shots before you commit them to expensive photo paper. In other words, the photo printer is at its best for a quick evaluation of what you're shooting, but you'll want to step back to computerised editing for your best shots.

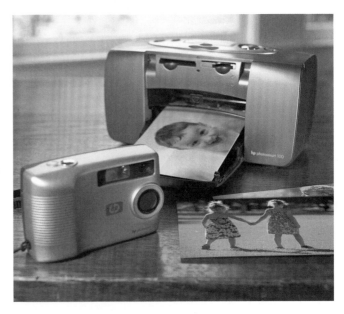

A dye-sublimation printer.

## Dye-sublimation printers

The best photo printers – at one time, the only printers to wear the 'photo' designation – use dye sublimation technology. That is, the depth of a colour is set by how deeply the dye or ink penetrates into a special paper. Professional digital prints at one time used dye-sublimation techniques exclusively, although better quality inkjet printers are elbowing the more expensive machines aside.

Instead of dithering dots to blend colours, the dots of a dye-sub printer are the actual colour they show. In effect, a dye-sub printer can make a grainless print. As a result, dye-sublimation printers with lower resolution (often as low as 300dpi) can produce results better than an inkjet with 1,440dpi resolution.

Dye-sublimation printers, and the paper they use, are more expensive than the inkjet equivalents, so the technology never moved into the mainstream. Ordinary inkjet technology has improved to the point that most people find it acceptable, so dye-sub technology has become rare.

When a dye-sublimation image, like that on the left, is magnified, no grain is apparent.

PART  **Paper**

Fell a tree, dissolve it in water with the most vile chemicals you can imagine, wring it out, and you have paper, ordinary paper, the stuff that (in excess) built modern civilisation. Paper is that un-ecological substance we rely on for our photo prints.

Not all papers are created equal, however. Paper runs a wide range of qualities and prices – literally from a penny to a pound per sheet. Some are more suited to your printouts than others.

**Plain paper** is the least common denominator among papers. By definition, plain paper can be anything, but typically it is the stuff once termed 'typing paper' by people old enough to have once typed. About the only things for sure about plain paper are that it has more acid in it than a theatre review and has only one aim in life, returning to the dust from which it was made.

Plain paper is highly absorbent, which means, for photo print purposes, it will suck in ink like a dishcloth, giving you dull, fuzzy prints. Use it only for drafts or finding the exact size an image will print.

**Inkjet paper** is tailored with specific absorptive characteristics so that it sucks in neither too much nor too little ink. Individual dots remain distinct on inkjet paper, so images appear sharper than they do on plain paper. Because ink still sinks into inkjet paper and the dull, flat surface of the sheets, photo prints made on this material (though sharp) look dull and lifeless. Inkjet paper is recommended for everyday printouts, particularly text, but not for quality photos.

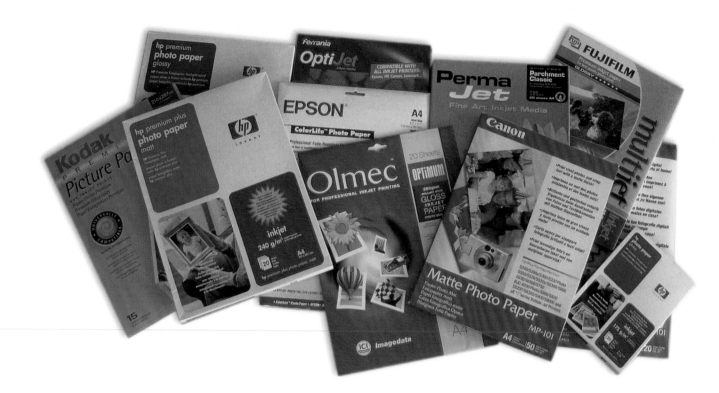

**Coated paper** has a clay or gelatin coating that makes each sheet shiny. It can also prevent inkjet ink from soaking in. The ink stays on the surface, giving a deep, wet look – which often remains wet (and subject to smudging) for far too long. When dry, the ink may still smudge or brush off. Ordinary coated paper is not suitable for inkjet printing unless specifically designed for inkjet use.

**Glossy photo paper** is specifically engineered to give a true photo look to inkjet printouts. It features a clear coating that absorbs ink to give a gloss and depth to images. It is also the most expensive paper sold for inkjet printers. If you want your printouts to look like photos, you'll have to use this kind of paper – which is why manufacturers get away with charging so much. Some paper companies offer a matt-finished version of the same paper. It uses the same inkjet-friendly coating with a surface altered to reduce the shiny gloss.

## Paper qualities

Not all papers are the same. Several characteristics distinguish different papers making some more suitable for your photographs. These characteristics include weight, reflectance, acid content, composition and finish.

**Weight** For text printouts, paper thickness is often designated in basis (sometimes basic) weight, measured (in the Imperial system) as lbs per ream (500 sheets) of a characteristic size or (in the metric system) as grams per one-metre-square sheet. Photo papers are described more simply as single-weight or double-weight, the former for economy, the latter for longevity. Most photo-quality inkjet papers are the equivalent of double-weight.

**Reflectance** For text printouts, reflectance describes how white each sheet is by how much light each reflects. Common papers range from 82% to 94%. To produce the most contrast, photo papers should be as bright as possible. Most glossy photo papers incorporate pigments like titanium dioxide to make them very bright.

**Acid content** Acid causes paper to age, making sheets yellow and brittle. Non-acid papers are buffered to prevent this deterioration. To make lasting photo printouts, look for non-acid paper. Not all glossy photo papers are non-acid.

**Composition** Papers are made from cellulose fibres that can have their origin in cotton or wood. Cotton fibres are longer, making stronger paper, but are more expensive. Only the best papers are 100% cotton (or rag) based. Most photo papers are not, achieving their strength instead through thickness.

**Finish** Many photographic papers are resin (plastic) coated to avoid absorbing photo chemicals. Glossy photo paper for inkjet printers usually is not (but this makes no difference because inkjet printing doesn't use those nasty chemicals). Instead, glossy photo paper for inkjets has a deep, clear, absorbent coating that gives photo-like depth like real gelatin prints. Some photo papers have a textured finish, simulating canvas or watercolour papers.

PART  # CDs and DVDs

If you've been an avid photographer for more than a few years, you probably have boxes of slides – or rooms full of boxes of slides – images you've collected over your lifetime. At some point, storing them becomes a problem and may tempt you to larger quarters.

Digital photography makes matters more compact. You can fit 100 or more images on a single disk that takes up a fraction of the space of a single roll of film. Opt for the best in modern technology, a Digital Versatile Disc (DVD), and you can store a thousand shots on one disc. Your collection takes on truly minuscule proportions.

The chief differences between the two technologies are cost and capacity. A DVD holds roughly seven times more data than a CD, so you can store more images in one place. But a recordable CD currently costs less than a tenth of a recordable DVD, so the CD is the more affordable alternative. And that's not counting the cost of entry. You can get a CD drive for under £50 while a DVD may cost five times more.

There's one more issue, compatibility. A CD will play on any drive, CD or DVD, and you can use the same drive to make photo albums, data discs and music. While a DVD offers similar versatility, the discs work only in DVD drives. If you have friends or family who are stuck with a drive from a few years back, CDs may be all they can use.

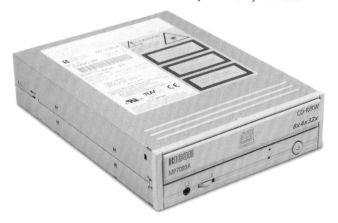

## CD drives
CD drives come in three types:

**CD-ROM** drives are readers that can only play back. They are inexpensive but useful for viewing archives.

**CD-R** drives can write to blank discs, but the material from which the discs are made accepts only one writing. In other words, they make permanent archive, exactly what you want to warehouse your images. You can exchange CD-R discs with friends and family. The drives also read factory-written discs, data and music.

**CD-RW** drives work with CD-R media like CD-R drives but with CD-RW discs they can write and rewrite like a conventional hard disc. The problem is that until a new standard called Mount Rainier becomes universal among drives, CD-RW discs can be read only in the drive that makes them unless you convert them to CD-R format. Then again, you can make readily interchangeable CD-R discs with the same drive.

In that a CD-RW drive can do everything a CD-R drive can – and more – and there's little price difference, opt for the CD-RW drive. In fact, you may have to because the advantage of CD-RW has become so obvious that CD-R drives are now hard to find. Look for one that claims Mount Rainier compatibility.

## DVD drives

DVD drives come in the same three flavours as CD drives, but are further complicated by several competing standards among rewritable drives. As with CDs, the write-once discs are compatible across different drives, but compatibility of rewritable discs is far less assured.

DVD-RW and DVD-Multi are formats promoted by the DVD Forum, which counts among its members the originators of the DVD. It is at its best as a sequential medium, which makes it a good choice for movies but not so for data and still images.

DVD+RW is aimed more at random access applications. It is supported by the major computer makers, including Hewlett-Packard and Dell.

## Installation

Many new computers come with a CD-RW drive. If yours does not, you can easily add one, at least if there is space in your system. You can also replace a plain CD-Rom drive with a CD-RW.

Set the Master/Slave jumper on the drive. Make it a 'slave' if another drive will connect to your computer on the same 40-pin ribbon cable; 'master' if it is the only drive on the cable.

Open your PC's case.

If replacing a CD-ROM drive, unscrew the drive, pull it partly out, disconnect the cables from the rear of the drive, and fully remove the drive from the computer.

Slide the new drive into its approximate place without screwing it in.

Attach the 40-pin drive cable to the drive, the four-pin power connector and the small audio connector (if replacing your old CD drive).

Put your drive in place and screw it in.

Close the case and install the software accompanying the drive.

# PART **CD tips**

## File archive
To preserve your photos for future use, before and after editing, you'll want to make a CD archive. You only need to copy your raw image files to the CD. You might want to include thumbnail files and display software so you can be sure you can view your photos on any system at any time.

## Exchange CD
When you want to exchange files with friends and family, edit first. Use only your best photos and choose a common and convenient format. You'll do your viewers a favour if you keep image size and orientation the same for each shot. Although including viewing software can be a big convenience, you cannot legally distribute a copy of a commercial program, so look for a small freeware viewer and format to match.

## Slide show
As long as you have all of your photos in a common format, you might as well arrange them into a slide show. You can use Microsoft's PowerPoint or any other slide viewing program as your projector. Many will give you the option of including your own narration. Beware of copyright issues, however, if you are thinking of distributing commercial software or music.

## Autorun step-by-step
Making a slide show to share with your family is a great idea. The only thing better is an Autorun slide show on CD. Your recipient need know nothing about computers – slide in the disc, and it will automatically start showing your slides, even playing your narration.

You can use any slide show program to make an Autorun CD. The following example uses PowerPoint, a popular presentation program included in the Microsoft Office suite.

*Create a text file called autorun.inf using Notepad.*

*Type the following into the file and save:* [autorun] open=ppview32.exe prevent\ [your presentation name]

Move the file to what will be the root directory of your CD.

Copy the following PowerPoint files into the root directory of your CD.

Base.srg
Pp4x322.dll
Pp7x32.dll
Ppintlv.dll
Ppview32.exe
Rappt.dll

Selfreg.dll
Servrdep.srg
Servrind.srg
Sshow.srg
Docobj.dll
Hlink.dll

Hlinkprx.dll
Msimrt.dll
Msimrt16.dll
Msimrt32.dll
Msimusic.dll
Mso97v.dll

Msorfs.dll
Msppt8vr.olb
Msv7enu.dll
T2embed.dll
Urlmon.dll
Wininet.dll

Create a folder that will appear on your CD as '\present' (without the quotation marks)

Put your slide-show files in the '\present' folder.

Create a folder that will appear on your CD as '\setup'.

Put the driver ppview.dll into the '\setup' folder. Burn the CD.

# PART 7

# Making a CD

Burning a CD is not a skill. It's work. But once you know the drill, you'll be an expert. And today's CD burning software makes the job easy. Most programs are menu-driven and only require that you drag-and-drop files with your mouse to get them onto CD.

If you haven't already guessed, burning a CD means recording files on it, typically music or your digital photo images. Although you should be able to burn a disc in minutes after installing a drive, you'll find there are some hidden issues that no one warned you about – but we will.

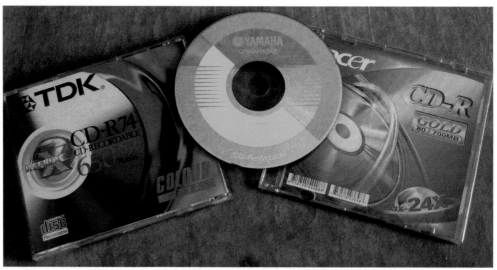

## Choosing blank CDs

The most economical way to store your digital photos is to fill CDs with as much as they can hold. Most CDs are rated by playing time, either 72min or 80min. These capacities translate into 640 megabytes or 720 megabytes, respectively. Outwardly the discs are identical, and either one will play (if properly burned) in any drive. Because of overhead – lead-in tracks, lead-out tracks and file inefficiencies, however, no CD will hold its rated capacity in megabytes. Only your CD burning software knows for sure how many files will fit; you should be safe if you target the rated capacity minus five to eight per cent.

CD-RW drives are speed rated, usually something like 16/8/48. The slowest speed (8) is the rewritable speed; the middle speed (16) is for CD burning; the highest speed (48) is reading only. Blank CDs are also speed rated. Choose CDs with a rating equal to or greater than the speed of your drive.

Blank CDs also come in a variety of colours – the recording surface can be silver, gold, green, or blue, and the rest of the CD may be tinted any colour, including black. No matter what audio purists say, the colour makes no difference. It is merely cosmetic. (The only way to change the sound of a CD is to change the actual digital code, which the colour cannot do – error correction assures every bit is the same all the time.)

# The slow burn step-by-step

**1**

**Determine** *the photos you want to store. Save up a disc full before you begin so you don't waste CD space.*

**2**

**Create folders** *to organise your photos. The most straightforward way is to make a folder for each assignment, trip or event. Move your files into the folders.*

**3**

**Slide a blank CD** *into your drive. Be sure to choose the right speed and size for drive and images.*

**4**

**Open your CD** *mastering program by clicking on its icon. Some will start automatically when you load your disc into the drive.*

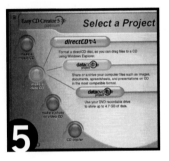

**5**

**Choose to make** *a data CD. Although you're going to make a photo album, your image files are simply data to your computer and drive.*

**6**

**Drag your** *directories that you created in step two and the file in them into the CD directory area of the CD burning program. You don't have to deal with individual files. Dragging only the directory will move their contents – your images – into the program.*

**7**

**Click the** *record button. You can choose the highest speed compatible with your drive or let the software choose for itself. The software should take care of the rest for you.*

**8**

**Label the CD** *after you check that you can open your images. You can use a water-based marker or, for a more finished look, a CD labelling system.*

# Posting images on the web

Your web page is your personal soapbox to lecture the world, a bulletin board that can help keep far-flung families together, a gallery to show your photographic mastery and much, much more. Anyone can create a web page. You need only a web hosting service, and most Internet Service Providers (ISPs) who provide you a place to connect to the Web also give you a free web page of your own. Most let you do anything you want with your page – at least anything legal.

Along with your page, you're also apt to get a rudimentary tool to craft the page you want. But if you want to do the best job, you'll probably want a program aimed at producing professional (or professional-looking) web pages. In general, these programs are classified as web authoring, and they let you choose how to lay out your web page using menu selections and your mouse. They draw together text and photos from other files to create a complete page or series of them.

## WEB RESOURCES

Web authoring software runs a wide range, from entry-level Microsoft FrontPage to the powerful designer's tool Macromedia Dreamweaver MX. Some of the most popular authoring tools include:

Adobe GoLive, www.adobe.com/products/golive/main.html
Macromedia Dreamweaver MX,
www.macromedia.com/software/dreamweaver/
NetObjects Fusion, www.netobjects.com/
SoftQuad HoTMetaL Pro, www.softquad.com
Microsoft FrontPage, www.microsoft.com/frontpage/

## Inserting photos step-by-step

With most web authoring programs you can insert photos onto a web page in two ways, reading a file and pasting from the clipboard. Pasting from the clipboard lifts the pixels displayed in one program and transplants them into your web software page. If the software has reduced image resolution to display it on the screen, you'll capture and paste the reduced-resolution version of the image. When you insert a file, you add the image in all of its glory, every dot and colour. Most web software will later let you jump to a graphic editor to modify your image, for example, crop or adjust its size.

# Copy-and-paste method

**Open the image** *by clicking on its icon or by reading into a program capable of displaying it. Right click on the image to pop up the menu.*

**Select** *copy from the menu.*

**Shift** *to your web authoring program.*

**Place your mouse** *where you want the image to appear.*

**Click on the right mouse** *button to pop up the menu, mouse on paste.*

**Select paste** *to paste the image in place.*

# Insert menu method

**1**

*Place your mouse* at the location you want the image to appear and left click.

**2**

*Click insert* menu option, then Picture, then From file.

**3**

*Type in* the filename of your image or browse for it.

**4**

*Click OK.* Your image should appear in your page.

## Size and resolution

Most web-authoring software allows you to insert an image at one resolution but display it at another, relying on the browser software to adjust the size of the displayed image. Although this option can make laying out pages easier, it also slows page loading – the browser must download the full image even if it is to display at a fraction of its size. If you want to put a thumbnail on a page to point to a high-resolution version of an image, use a separate, small thumbnail image that's scaled before you put it on the page.

The primary trade-off is bigger means longer downloads (and uploads, should you post a lot). In general, you won't want to post images larger than 640 x 480 pixels, nominally a full screen. For snapshots, consider quarter-size images, 320 x 240.

## Image index

A more effective way to display images on the Web is with a quick-loading index that presents small thumbnails linked to full-size images. You allow browsers to quickly load your page and preview your pictures, then zero in on those of interest for viewing in detail and printing.

PART  # E-mailing images

Thanks to e-mail, you can send your digital photos anywhere in the world in an instant (or slightly longer, depending on your modem).

In e-mail images you have two choices for packaging and sending them. You can *embed* them in your message or your can attach them as files. Each has its advantages and limitations.

## Embedded images

An embedded image is part of your message along with your text. When your recipients open their e-mail, your image will pop into view along with your words.

Embedding requires that both you and your recipients have eight-bit messaging capabilities, because you both must have the ability to read graphics along with text. You want an e-mail program with the capability of sending and reading HTML (Web format) files.

Microsoft *Outlook* and Netscape *Communicator* both have the required power. As a default, *Outlook* will use ordinary ASCII (text-only). To change the message format, open a new message, then click 'Format', then 'HTML'.

You don't have to compose HTML pages in your e-mail program. You can use website software to create an HTML page and simply paste it into your e-mail program's editor.

To embed an image, type in your message, and when you reach the point where you want your picture to appear, simply drag the image file into your message. Or click Insert on the menu bar, then Picture, specifying the file containing it.

Nothing but good taste limits the size of images you can

embed. You could put a full-size six megapixel picture in straight from your camera, but it will spill over the electronic page of your e-mail (and take forever to download). You'll want to limit your images to more normal display size as you would use for a web page (for example, 320 x 240 pixels).

## Attached images

Attached images accompany your e-mail message as image files. Your recipient doesn't see your image when reading your message. Viewing it takes a separate step – the recipient must use a graphic viewer of some kind to see the image. Microsoft's Internet Explorer will show most common formats, including JPEGs, GIFs, and BMPs.

To the e-mail system, all attached files are the same. It doesn't care whether they are images, data or word processing files. The same size and coding limitations apply to all attachments. Many corporate e-mail systems purposely limit the size of file attachments, so multi-megabyte images quite likely won't be delivered.

In addition, many old Unix-based e-mail systems require seven-bit encoding for file attachments (and only allow text for e-mail messages, so no embedded pictures). You'll need to encode your image file in MIME or similar seven-bit format for sending.

Because attached images don't compete with the text of the message, not even good taste limits your choice of image size. You can send full-resolution images straight from your camera. In fact, you'll want to do exactly that if you're e-mailing your images for on-line printing.

An embedded image displays as soon as your recipient opens his mail.

To embed photos, you must encode your email at HTML.

Don't embed full-size images from your camera. Lower size and resolution or make high-resolution photos into attachments instead.

# PART 7 Digital picture frames

The digital picture frame looks like you pushed all those computer circuits off your desk and plopped down a cheap snapshot frame. A big yawn – until you turn one on!

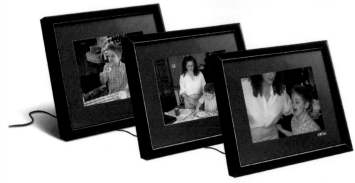

A frame you turn on? Yes, and it snaps to life with a full-colour LCD image, all-digital from camera lens to your eye. Certainly any photo on your desk can start a conversation, but the images on a digital frame will start each one with a 'Wow!'

A digital picture frame is like a small LCD monitor optimised for photos, but most models add more. They let you exchange photos through the Internet, even update the photos on grandma's dresser. Some will play videos. The products are too new for much standardisation of features, but thankfully they accept today's current standards in image and media formats. Although the resolution of the on-screen (or in-frame) images is low, the screens are small enough for the pictures to look sharp and convincing.

Most frames are more than static displays. They change photos either at your command or as automatic slide shows – either snapping between pictures or using elaborate digital dissolves between frames. Most have their own built-in storage that varies in capacity from 10 to 36 images. Most let you supplement their internal storage with your camera's memory cards – typically the same CompactFlash cards you use like film in your digital camera), some even let you store images on-line.

Of course, you can use your computer to create or edit images that you later display in a digital frame. You only need store them in the familiar JPEG format, which all of the frames understand. Although most frames are designed for VGA resolution (640 x 480 pixels), they readily accept images of different resolutions and interpolate them to fit on their screens.

## Cyberspace frames

Some digital frames venture off into cyberspace. Plug a phone wire to a jack on one of these frames, and it will make direct contact with the Internet, no computer required. These special frames can automatically download images that you or your friends send forward through special dial-up services (for which you must pay a subscription in addition to the purchase price of the frame).

In addition, the Internet services allow you to exchange photos with friends, pop surprise images into digital frames (say a granddaughter wishing you happy birthday), and even make hardcopy prints of your digital photos – for a monthly fee, of course.

## Convertible frames

Most digital frames work on your desk or hanging on the wall, but be aware most require power connections, so you'll have a wire draped down your wall. Most let you set them as portrait or landscape frames, but you'll have to twist the frame yourself to adjust it if you plan a show of mixed-orientation images. One model has a position-sensing switch which adjusts the bright active-matrix screen so you can rotate the frame for horizontal (landscape) or vertical (portrait) orientation, and the image always stays right-side up.

Although designers appear to prefer the high-tech polished metal (or plastic look), you can often exchange faceplates to suit your décor.

## Pocket-size photos

Frames also come in pocket-size, meant to be digital stand-ins for wallet photos. Although their smaller screens have lower resolutions (say quarter-VGA, 320 x 240 pixels), they make up for it with the convenience of battery operation. As with old wallet photos, you can pull one out of your pocket to show off pictures of your children, although current technologies leave the portable frames too fat and fragile to stuff in your back pocket.

## Big screens

If you want to make a real display, you'll find frames with images as large as computer monitors, 17in across, which accept any conventional 16in x 20in picture frame, so you can match the Rembrandts on your walls. The current model even has a built-in CD drive so you can program a slide-show of your entire two-month holiday.

### WHERE TO FIND THEM

Some of the places to find out more about digital frames on the Internet include:

**Internet-connected frames**
Ceiva at http://www.ceiva.com
**big-screen frames**
Digi-frame at http://www.digi-frame.com
**wallet-size frames**
VideoChip at http://www.videochip.com

PART 8

DIGITAL PHOTOGRAPHY MANUAL

# Appendices

# PART

# Appendix 1
# Image and file formats

Whenever you post, exchange or save files, the format of the data becomes important. The format you choose must be one that can readily be used by the software you or your recipient uses. Although the digital photograph files from your camera can be used by most modern applications, it is not always the best choice. For various reasons, other formats may work better in some applications.

GIF files use palletised images. Your photo editor will reduce the number of colours needed to encode each image.

## File formats

The six most common image formats are TIFF, PSD, BMP, PCX, GIF, and JPEG.

**TIFF** (Tagged Image File Format) was designed specifically for versatility. They can be compressed or uncompressed and store images at any resolution or bit-depth. They are often used where the highest-quality images are demanded, such as commercial publishing.

**PSD** (Photoshop Document) files individually preserve the layers created in editing in Photoshop (and related programs) so that you can go back and work on them separately.

**BMP** images are raw data, uncompressed. Think of the name as a contraction of 'bit-map'. They contain all the image information of the original, all the dots, all the colours. Because everything is there, BMP files are filled with huge amounts of data. They are the largest, most cumbersome files to post on the web, but are the most compatible with different applications. Use BMP for storage when you don't know what program you'll use for viewing and editing, but not on the Web.

 COMPRESSION

File compression makes most files smaller so you can send them faster over the Internet. Programs such as *WinZip* shrink the size of files by finding more efficient ways of coding information and eliminating redundancies. For example, a sky may be covered with 10,000 pixels that are all the same colour. Without compression you would have to store 10,000 pixels' worth of information, but a compression program might use only a handful of bytes, a couple to indicate the colour of the pixels and a few more to indicate how many pixels are to be rendered in that colour.

File compression works well on images. About 80% of the data in an image file is redundant and can be eliminated through compression. The compressed data, whether text, photos or something else entirely, is always stored in file with the .zip filename extension.

Be aware that in most cases ZIPping a photo file is counterproductive. The two most common image formats, JPEG and GIF already use the algorithms similar to those used by ZIP (and related file compression programs), so you gain very little from the added complication of compression. Only BMP files compress well, and they are not commonly used for photos.

**PCX** files keep all your dots and colours but add in compression to make them more compact. PCX is a popular format for saving images for on-paper publishing but is almost never used on the Web – most browsers don't even know how to deal with them. The name of the file format comes from the old program PC Paintbrush, for which the format was developed. PCX reduces file size by about two thirds by palettising colours, reducing the total number to 256, enough for effective rendering of photos. GIF (Graphic Interchange Format) files preserve the dots but not the colours of your images. GIF uses a common (but patented) compression scheme to reduce the number of dots by compactly coding long strings. GIF is the most popular web image format.

**JPEG** (Joint Photographic Experts Group, which developed the compression scheme used by the files), pronounced jay-peg and shortened to 'jpg', reduces detail but not colours using a sliding compression scale – you trade off detail for smaller files. Because it uses a perception-based compression algorithm, JPEG yields the best compromise of size for detail, making it the choice of camera-makers. It is popular for the web, especially when you need compact files.

Jpegs create problems when highly compressed as the colour information becomes blocked and affects picture quality, often showing patterns known as artefacts. Here these can clearly be seen in the leaves of a pineapple.

## Which to use

The native format of most digital cameras is jpg, used because the sophisticated JPEG compression algorithms offer the best compromise between small file size and image quality. Most graphics programs now handle the format adroitly, as do most web browsers. This format is the top choice for storing your images as raw shots and touched-up photos. It is sometimes used on the Web, particularly when you want full colour capabilities. The jpg format permits an infinite range of compression so you can make files as small as you want – taken to the extreme (or even just beyond moderation) and the compression becomes obvious. The chief artefacts are the image breaking into large squares with apparent edges. (Most digital cameras define their image modes by the degree of JPEG compression employed.)

The most popular format for the Web is GIF. It is easy for any program to decode and it offers fixed, moderate compression through a well-understood (and patented) algorithm. Use this format for posting images on web pages.

The BMP format, simply being pixels in an array, is the most basic of all formats. Any computer running Windows can open a BMP file. Use this format if you're uncertain of the sophistication of the recipient or, for long-term storage, if you're uncertain other formats will remain popular for the next few decades.

The PCX format was once common among desktop publishing programs. Although it is now declining in popularity, many old programs still prefer the format.

## FILE FORMATS AND USES

| File type | Allows compression | Ideal for Web use | Preserves layers | Use in DTP layouts | Saves selections | Preserves clipping paths | Best for Archiving |
|-----------|-------------------|-------------------|------------------|--------------------|------------------|--------------------------|--------------------|
| JPEG | Yes | Yes | Yes | No | No | Yes | No |
| GIF | Yes | Yes | No | No | No | No | No |
| TIFF | Yes | No | Yes | Yes | Yes | Yes | Yes |
| PSD | No | No | No | No | Yes | Yes | Yes |

# PART 8

# Appendix 2
# Managing images

When it comes to storing photos, your digital camera leaves you in the wilderness. Download a photo, and you get a name as exciting and informative as DCP0001.jpg. Reuse your memory card, and the first shot you take is DCP0001.jpg all over again. Pretty soon you have a hundred of them, and – wait, you just took another picture – 101. Which one had the Loch Ness Monster actually touching noses with your granddaughter?

If you take more than a dozen digital photos, you're a candidate for image management software. These specialised programs operate as filing systems for photos. Although you can keep yourself organised using the basic features of your operating system (storing related photos in individual folders or directories), image management programs add a wealth of welcome features. Some of these include:

**File management.** Management software allows you to move and copy images from a single coherent interface that works in concert with its other functions. They force you to organise and store your images so you can find them when you need them.

**File transfer.** Image management programs can take over the details of moving your images around, downloading them from your camera or uploading them to the web. Because a single program handles all the transfers, you're less likely to make mistakes.

**Format conversion.** Many image management programs let you convert files between different formats. Many have rudimentary photo-editing capabilities so you can change the size of images, rotate and crop them.

**Comments.** Image management software allows you to attach comments to your photos (in addition to those added by your camera) so you can add a story, description or technical details to each photo for future reference. The comments are stored as data, attached to the image but invisible when you want to view only the photo. Use comments to supplement your memory or provide guidance to your literary executor.

**Printing**. Many image management systems have integral printing utilities that allow you to size and print images, including arranging image thumbnails like a classic contact sheet. You can see at a glance all the photos from a session, keeping the sheets in a binder or album for instant reference without warming up your computer.

**Display**. On-screen displays, including slide shows. Split-screen view lets you compare images. A magnifying glass or zoom feature will let you check details.

**Search**. When you want to find a particular image, a search feature helps you find it fast. You classify each image by its contents when you store it, and the search feature can retrieve photos based on your classification, date or even the comments you append.

## On your own

You don't need any special software beyond Windows to manage an image collection. If you store your images in one of the big three formats, Microsoft's Internet Explorer will give you a preview of each file in its 'Thumbnail' mode.

Choose thumbnail mode by clicking 'View' then 'Thumbnail' in the directory you want to view. Click on an image thumbnail, and recent versions of Internet Explorer will open and display your image full-screen (reducing large images to fit).

But printing is another matter – one for which you'll find an image management program invaluable.

### WEB RESOURCES

A selection of image management products:

**Adobe ActiveShare**, www.adobe.com/products/activeshare/main.html
**Andrikkos Imagine!**, www.andrikkos.freeserve.co.uk/
**Firegraphic** Firegraphic XP, www.firegraphic.com/products/firegraphicxp/
**ISS imagENGine**, www.insyse.com/
**Photools IMatch**, www.photools.com/
**PKZSoftware** PhotoLibrary, pages.zdnet.com/pkzsoftware/
**PrimaSoft** Photo Organizer Deluxe, www.primasoft.com/deluxeprg/photo_organizer_deluxe.htm
**Pro Shooters** DigitalPro, www.proshooters.com/

# PART 8 Appendix 3 Glossary

### a

**Aperture**. The variable opening inside the lens, which regulates the intensity of light striking the image sensor. Measured in f-stops. A side-effect of altering the aperture is the change in depth of field, which declines as the aperture opens wider.

**ASA**. An acronym for American Standards Association, although used to describe one of the organisation's standards for measuring film speed on a linear scale. Equivalent numbers are now used by some digital camera makers to describe the sensitivity of their products.

### b

**Backlight compensation**. A control on some digital cameras that adjusts the exposure for subjects that might otherwise be silhouetted against a bright light source. Typically the control opens the aperture by one or two stops (or lowers shutter speed) to overexpose the overall image.

**Barrel distortion**. The change in shape of objects by an inferior lens which causes lines parallel to the edges of the frame to bow outward in the middle.

**Buffer**. Digital memory used for temporary storage. In a digital camera, a buffer stores the image registered by the image sensor until it can be copied onto a memory card. A large buffer helps a camera handle quick bursts of exposures.

### c

**CCD**. An acronym for Charge-Coupled Device, a technology used for image sensors.

**Chromatic aberrations**. A defect in images rendered by a lens caused by different colours coming into focus at different points. In severe cases, it results in fringes of colours around objects.

**Colour temperature**. A technical description of the hue of light illuminating a scene, expressed in degrees Kelvin, referring to the radiation of a perfect black body at that temperature. In practical terms, tungsten lamps have a colour temperature of about 3,200° Kelvin; a sunny day, about 5,500°; open shade, nearly 10,000°. White balancing corrects for the colour temperature.

**CompactFlash**. A standard for memory cards that is essentially a notebook computer PC Card reduced in size. Current cards store up to 1GB and allow for 1GB micro hard disk drives.

### d

**Depth of field**. The range of distances that appears to be sharp or in focus in a photograph. On a given focal length lens, smaller apertures yield larger depths of field.

**Digital camera**. A device that captures a scene as a representation in a digital code in which numeric values encode the colour and brightness of elements of the scene.

**Digital zoom**. A zoom-like effect enlarging the central portion of a scene.

**Downloading**. The process of transferring files from a digital camera or other source to a computer or printer.

**DPOF**. An acronym for Digital Print Order Format, a file format that stores commands for photo printers and printing services that indicates which images to print, how many copies of each, and other information.

**Effective pixels**. Describes the number of pixels stored in the image files made by a digital camera regardless of the number of pixels in the image sensor. The number is always less than the pixels on the CCD as some pixels around the edge may not be used and are only produced to help improve accuracy on effective pixels.

**Exposure**. The product of the time the image sensor receives light (shutter speed) and the intensity of that light (lens aperture). The same term is often used to describe the image made during an exposure.

**Exposure value**. A numerical description of the exposure, typically normalised to a single digit number. Used in manually setting of shutter speed and aperture.

**Flash memory**. The technology used by memory cards. A kind of solid-state memory that is electrically changeable and retains those changes even in the absence of electricity.

**Focal length**. Technically, the distance between the nodal point of a camera lens and where a subject at infinite distance in front of the lens appears in focus behind the lens. The focal length is more usually used to indicate image magnification, most often in terms of the 35mm film format. A 200mm lens offers four times magnification over a standard 50mm lens which is roughly the magnification of our eyes.

**F-stop**. The ratio of the lens focal length divided by the apparent aperture of the lens. Used to describe lens aperture, either as the maximum lens opening (a 50mm, f2 lens) or as a setting that controls exposure (stopping down to f16).

**Gamma**. The mathematical relationship between two tone curves, the practical effect of which is to change the contrast on your monitor screen.

**Guide number**. An indicator of the intensity of a flash unit at a given film speed. The guide number divided by the distance to the subject equals the appropriate aperture f-stop setting.

**Image sensor**. A light-sensing semiconductor circuit made of millions of individual light-sensitive elements arranged in an array on which the camera lens forms its image. The image sensor turns the pattern of light into a pattern of electrical signals that the camera converts into digital form and saves.

**Infrared**. Light with a wavelength longer than can be perceived by human vision. Intense infrared can be sensed as heat. Some digital cameras are sensitive to infrared and can make exposures at longer wavelengths. This invisible light is also used to signal some remote controls and transfer files from camera to computer.

**Interpolation**. The mathematical process of creating pixels that appear in between other pixels as an image is magnified. In common usage, an interpolated image is one made larger but not sharper by adding interpolated pixels.

**Iris**. The small blades inside a lens that shift to alter the aperture of the lens.

**ISO**. An acronym for the International Standards Organisation, commonly used to designate speed ratings of film on a logarithmic scale.

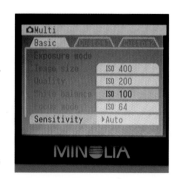

**JPEG**. An acronym for the Joint Photographic Experts Group and used to designate an image compression system developed by the group. This format is used by most digital cameras because it yields high compression ratios (small files) with little apparent image degradation.

**LCD**. An acronym for Liquid Crystal Display, a low-power flat-panel display system. LCDs are used for the monitors built into notebook computers and for the small view screens on many digital cameras.

**Megapixel**. One million pixels. A number often used to indicate the resolution capabilities of a digital camera. Pixels and megapixels are counted by taking the number of pixels that appear horizontally and vertically across an image. A camera that produces a 1,500 x 1,000 pixel image has a resolution of 1.5 megapixels.

**MemoryStick**. A proprietary package for flash memory developed by Sony Corporation for its digital cameras, MP3 players and other electronic devices.

**Optical zoom**. The alteration of the effective focal length of a lens and hence the size of the image produced by a given subject by changing the optical formula of the lens. The number of pixels used in constructing the image remains constant (there is no digital interpolation) so quality is constant and higher than in digital zoom.

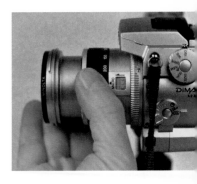

**Pan**. To pivot a camera on its vertical axis so that its subject field sweeps across horizontally.

**Pincushion distortion**. The change in shape of objects by an inferior lens which causes lines parallel to the edges of the frame to bow inward in the middle.

**Pixel**. A contraction of picture element. One position in an image for which light values are independently indicated or stored. A complete image is an array of pixels.

**Secure Digital**. A memory card standard with copy-management and security features.

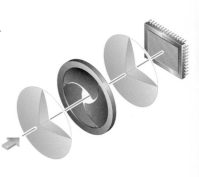

**Shutter**. A physical or electronic means of limiting the duration of the light exposure of the image sensor in a digital camera to both limit the intensity of light striking the sensor and to stop action (or not) in the photographic subject.

**Shutter lag**. The period between your pressing the shutter release and the camera actually making its exposure.

**Shutter release**. A control, typically a pushbutton, that a camera's operator presses to tell the camera to open its shutter and make an exposure.

**Shutter speed**. The duration the shutter remains open in front of a pixel in the image sensor during which an exposure is made. Shutter speed is usually measured in fractions of one second.

**SmartMedia**. A standardised compact package for flash memory chips used by many digital cameras. At one time called the Solid State Floppy Disk.

**Tilt**. To pivot a camera on its horizontal axis so its field of view moves up or down.

**White balance**. The process by which the intensity of each of the three primary colours of light is matched in a white patch in the image, thereby removing colour casts to the image resulting from different colour temperatures of the lighting.

# Index

 ACKNOWLEDGEMENTS

Thanks to my wife Tess and daughter Caelyn for their understanding and appearance in photos. Thanks also to the other photo subjects, including Jeff, Alex, and Michael Dreka, Sarah Printy, Jimmy Rohal, Jon Rosch and John Schoenbeck. And thanks to Frank Bican for the shot of the vintage Can Am race cars.

| | |
|---|---|
| Author | **Winn L Rosch** |
| Project Manager | **Louise McIntyre** |
| Designer | **Simon Larkin** |
| Technical Editor | **Peter Bargh** |
| Copy Editor | **John Hardaker** |
| Index | **Nigel D'Auvergne** |
| Illustrator | **Matthew Marke** |

## Photo Credits

Key: t-top, b-bottom, l-left, r-right, c-centre

**Action Plus:** 62b, 63b, 66 all, 67 all, 79bl, br, c, 80
**Peter Bargh:** 17tr, tl, 19tr, 21bc, 28bl, 29tr, cl, br, 30bl, 31tr, 34l, r, 35tr, br, 36t, 39t, 41cc, cl, 42r, 43b, 46t, b, 47 all, 48tr, bl, 49r, l, 50tr, tl, 51 all, 56, 64tc, tr, 65 all, 68t, 69br, 74 all, 76 all, 77 all, 79t, tl, 82t, 83tl, bc, bl, 84, 85tl, tr, bl, br, 87c x4, bl, 88bl, bcl, 89tl, 90, 91br, bc, 92l, tr, 93b x3, 94 all, 95tl, 99tr, 100bl, 101tl, bl, br, 103l x5, p111tr, 112 all, 113t, cl, cc, 114 all, 115 all, 118tr, tl, 121tr, tl, 134t, 137bl, 141, 144t, 146t, 156, 157, 159tl, tc
**Simon Clay:** 4, 8, 10, 11, 19b, 20, 21br, 23, 24, 52t, 53b, 58, 60, 62t, 72, 83tr, 91t, 96, 104, 105br, 132, 140, 154
**Stockfile:** 63t, 78
**Misc:** Foveon – 26t, Alan Benson – 28br, Phil Winn – 29tl, Nikon – 28t, Microtek – 57t,b, Martin Hyde – 64b, Serge Chabert (www.pwks.net) – 86, Tom Beardmore (www.DCResource.com) – 103cr, br, Will Smith – 149 all

All other images supplied by Winn L. Rosch or from manufacturers direct.